Marc Serota

About the Author

NORMAN F. CANTOR was Emeritus Professor of History, Sociology, and Comparative Literature at New York University. His academic honors included appointments as a Rhodes Scholar, Porter Ogden Jacobus Fellow at Princeton University, and Fulbright Professor at Tel Aviv University. His many books include the *New York Times* bestseller *In the Wake of the Plague; Antiquity; Inventing the Middle Ages*, which was nominated for a National Book Critics Circle Award; and *The Civilization of the Middle Ages*, the most widely read narrative of the Middle Ages in the English language.

Selected Titles by Norman F. Cantor

Alexander the Great

Journey to
the End of the Earth

NORMAN F. CANTOR
with
Dee Ranieri

HARPER ● PERENNIAL

NEW YORK ● LONDON ● TORONTO ● SYDNEY

HARPER ● PERENNIAL

A hardcover edition of this book was published in 2005 by HarperCollins Publishers.

ALEXANDER THE GREAT. Copyright © 2005 by The Estate of Norman Cantor. All rights reserved. Printed in the United States of America. No part of this book may be used or reproduced in any manner whatsoever without written permission except in the case of brief quotations embodied in critical articles and reviews. For information, address HarperCollins Publishers, 195 Broadway, New York, NY 10007.

HarperCollins books may be purchased for educational, business, or sales promotional use. For information, please e-mail the Special Markets Department at SPsales@harpercollins.com.

FIRST HARPER PERENNIAL EDITION PUBLISHED 2007.

Designed by C. Linda Dingler
Map designed by Paul J. Pugliese

The Library of Congress has catalogued the hardcover edition as follows:

Cantor, Norman F.
 Alexander the Great : journey to the end of the earth / Norman F. Cantor, with Dee Ranieri.
 p. cm.
 Includes bibliographical references.
 ISBN-10: 0-06-057012-1
 ISBN-13: 978-0-06-057012-5
 1. Alexander, the Great, 356–323 B.C. 2. Generals—Greece—Biography. 3. Greece—Kings and rulers—Biography. 4. Greece—History—Macedonian Expansion, 359–323 B.C. I. Ranieri, Dee. II. Title.

DF234.C26 2005
938'.07'092—dc22
[B] 2004059925

ISBN: 978-0-06-057013-2 (pbk.)
ISBN-10: 0-06-057013-X (pbk.)

HB 12.08.2021

To my students

Contents

Contents

Preface

❧

RECENT EVENTS in Iraq, Afghanistan, and the North-West Frontier Province of Pakistan have drawn our attention again to Alexander the Great. Three hundred years before Christ, this hero of antiquity led an army of Macedonians and Greeks on a route through the Middle East and Central Asia that intersected with the recent tactical deployment of the U.S. Army and Marines.

The first Western ruler to attempt a war of conquest in the Middle East and Central Asia, Alexander triumphed. But his army was no more comfortable than American forces have been in the difficult terrain and climate of Kabul, Baghdad, and surrounding territories.

In this book I have minimized the romance and fantasies associated with Alexander, trying instead to construct a critical and well-rounded assessment of the man and the world in which he lived.

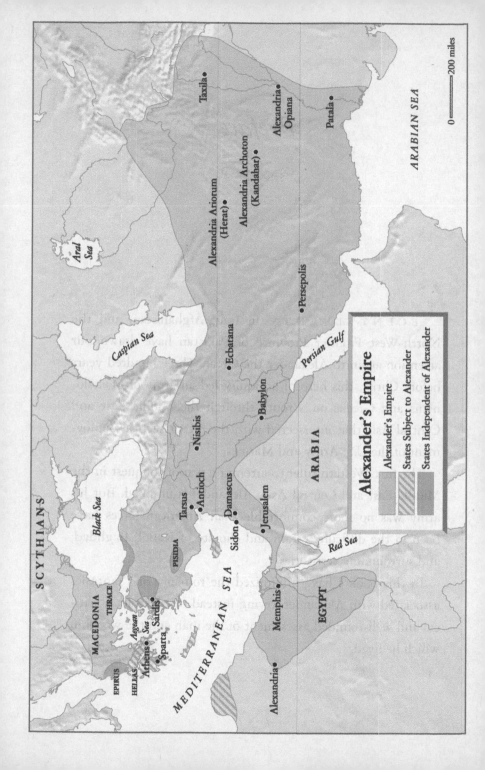

Alexander's Empire

Alexander's Empire

States Subject to Alexander

States Independent of Alexander

ARABIAN SEA

0 ———— 200 miles

Taxila

Alexandria Opiana

Alexandria Archoton (Kandahar)

Parala

Alexandria Ariorum (Herat)

Persepolis

Aral Sea

Caspian Sea

Ecbatana

Persian Gulf

Babylon

Nisibis

ARABIA

Antioch

Tarsus

Damascus

Sidon

Jerusalem

Red Sea

SCYTHIANS

Black Sea

PISIDIA

MACEDONIA

THRACE

Aegean Sea

Sardis

Athens

Sparta

EPIRUS

HELLAS

Memphis

EGYPT

Alexandria

MEDITERRANEAN SEA

ONE

The Greek World

𝒜NCIENT GREECE, extending from the king-
dom of Macedonia in the north down to the city-state of
Sparta in the south, was a large peninsula or archipelago jut-
ting out into the Aegean Sea. Much of its land was taken up
by forests, mountains, and deep valleys—a topography that
made unification of the Greek city-states difficult.

Up the coast from Sparta lay the rich and artistic city-state
of Athens—distinguished by its Parthenon, navy, democracy,
and opinionated orators—with the bustling port of Piraeus
some ten miles to the southwest. Thebes and Corinth were
other city-states, lying halfway between Macedonia and the
well-disciplined but bellicose Sparta.

The two principal forms of Greek culture stemmed from two periods of Greek history. The first, which could be called the Heroic Age (about 1300 to 800 BC), was an era in which kings like Agamemnon and Menelaus ruled, and their successes and failures were recounted in a grand oral tradition of heroic poetry. These rulers held on to a so-called shame culture in which honor and dignity were exalted and in which the worst thing was to be disgraced, to be without honor.

Reflecting this societal norm, the ten-year Trojan War allegedly occurred because a Trojan prince stole Helen, Menelaus's wife, and honor decreed that the king had to go to war to retrieve her. At the end of this period, around 800, in two epics, *The Iliad* and *The Odyssey*, Homer set down the oral traditions of the war, thus providing the written material for Alexander's obsession with Achilles. Homer's writings were a kind of light at the end of the tunnel of the Greek Dark Age. During this period there had been much jockeying for power among various peoples: the Dorians, the Ionians, and the Mycenaeans.

The years from about 800 to 500 BC are known as the Archaic Age. This was the period during which the city-state, or *polis*, was formed and the cities of the peninsula split into separate governmental bodies. This was also a time of great colonization, of Sicily and southern Italy. In art the human form underwent a transformation from an earlier style, in which it had looked almost like a stick figure, to the realistic portrayal of the human form in all its beauty that characterizes Greek art of the Classical Age.

From 500 to 320 BC, Greek—or at least the Athenian—culture underwent a radical transformation. In the words of Edgar Allan Poe, this was the period that gave the world "the glory that was Greece." It saw the rise of Athens and the building of the Parthenon as well as the democratic ideals and government of Pericles; the drama of Sophocles, Aeschylus, and Euripides; and the philosophical schools of Socrates, Plato, and Aristotle. This period also witnessed the development of the conflict between Persia and the Greek cities that finally ended with the rise of Alexander the Great.

For many years the city-states had fought one another over territory and commercial privileges in miserable, bloody wars. No one person had ever come along who was strong and ruthless enough to unite these natural enemies; thus there were only two exceptions to these dreadful—and futile—internecine conflicts. One was the period in the later fifth century BC when Athens and Sparta united during the Peloponnesian War against the menace of the Persian Empire coming over from Asia Minor. The alliance of Athens and Sparta defeated the Persians in the famous Battle of Marathon in 490 BC. After the war had dragged on for almost ten years, the Greeks forced the battle by advancing full force toward the Persian army and surrounding it. The Persians had no alternative except to retreat to their ships, heading south toward Athens to launch a surprise attack on the defenseless city. As they retreated, however, it occurred to the Athenian general that the city of Athens itself was defenseless, its citizens unprepared for

an attack. He ordered a soldier named Phidippides to run to Athens and bring them the news of the impending attack. Phidippides ran the distance of twenty-six miles in three hours (this was the birth of the marathon), delivered the message to the waiting city, and then promptly died from overexertion. In some versions of the story, Phidippides had already fought in the battle as well as having run to Sparta and back (about 280 miles in all) in the previous days—all his efforts culminating in his death from overexertion.

The only regular occasion on which the city-states were united was during the period of the Olympic games. At the games they discussed important political issues, celebrated common military victories, and even formed political and military alliances. Between about 700 BC and AD 400, every four years heralds were sent out from a small town near Mount Olympus declaring an Olympic truce, which lasted for the duration of the games and protected the athletes, visitors, spectators, and embassies from danger during the actual period of the competition. Most competitors were men and boys, but separate track events were held for unmarried girls (married women were strictly barred from the games). The men competed naked, their skin covered with olive oil. It was a highly competitive, heroic, largely masculine world. At the conclusion of the games, the city-states went back to fighting among themselves as usual for the next four years.

What was singular about Athens was its ribbons of colonies extending from the Black Sea to Asia Minor, to Sicily and

the south coast of France. Settlers had gone out from Athens, settled these far-distant places, and sent tax money back to Athens. In return they were governed by officials sent by the Athenian government. Though the Athenians' treatment of these colonies was harshly exploitative, the obvious power and strength of their navy kept most rebellion at a minimum.

In Athens itself at least a third of the population consisted of slaves. Some were domestic servants who were treated quite well; others did hard, forced labor in the mines or as oarsmen in multioared boats. (Some Athenian warships were rowed by as many as 170 slaves.) Athens was distinct in the ancient world because it was a democratic republic, though only about ten thousand adult males held the franchise, and the citizens engaged in noisy politics in a way very similar to the ones we associate with modern democracies.

Sparta, on the other hand, was a fearsome place run by oligarchic families who had experienced a disastrous near defeat by a group of rebellious subject people, the Messenians, and were so terrified by this brush with the obliteration of their society that they instituted what amounted to a military state. The defeated Messenians were made into helots, peasant serfs, forced to work the land under nightmarish conditions. They worked for the Spartan property owners, to whom they gave most of their produce, and were left only enough food for bare subsistence.

The male adolescents and young men in Sparta underwent many years of military training, causing them to regard

themselves as very special, in a sense resembling the U.S. Marines of today. Sparta was a society almost totally focused on war. Male children were judged at birth as hardy or weak, the latter being exposed to the elements and allowed to die. Boys remained with their mothers until the age of seven, when they were required to enter military training in special barracks where they would remain until they were thirty. The training, austere at best, taught the boys how to endure deprivation and extreme pain. The Spartan male's formal military training ended when he was twenty, but he remained a soldier and continued living a soldier's life. Though encouraged to marry, he could not live with his wife, except for brief periods to ensure pregnancies, until he was thirty. His military duties—like his other duties and responsibilities to the Spartan state—then remained until he reached the age of sixty.

In this militaristic society, interestingly, Spartan women had more freedom than most women in the ancient world. They were free to come and go in the city, perhaps because their husbands were not living at home. Girls were given vigorous athletic training and were also imbued with the idea that their lives belonged to the state.

Because they incorporated austerity, denial, simplicity, and self-discipline into both private and civil life, the Spartans believed that they were the true Greeks. When other so-called civilized city-states declined in strength and vigor, the Spartans pointed to their own "Spartan" lifestyle, which was keeping their city strong. Spartans lived and died for their city.

The rest of the Greek world was very different—consisting

by and large of mercenary, highly competitive, violent, slave-holding people. Upper-class Greek men were often bisexual, and with no social stigma attached to being openly homosexual, most of them took their pleasures from prostitutes or pubescent boys or both, treating their wives as mere breeding sows. Greek women had very little freedom, especially after marriage; they were usually veiled, as women generally are in Muslim countries today, and their freedom of movement was strictly curtailed.

An exception to the rule concerning freedom for women was the leading Greek woman poet, Sappho. Although she was married to a wealthy aristocrat, Sappho was able to live pretty much as she pleased. She chose to move to Lesbos, an island on which she lived with a group of young women and composed her lyric poetry (Lesbos, of course, is the source of the word "lesbian"). Because of some political intrigue in her family, she was forced into exile for a period of time, but eventually she came back.

In general the Greeks' attitude toward their deities was extremely negative: Whoever did not propitiate the gods could expect punishment. Therefore most Greeks made strenuous efforts to satisfy and placate the gods—led by Zeus—in their polytheistic pantheon. Some were aware of the concept of dying and reborn savior gods, but at the time of Alexander's birth in 356 BC, these were still local cults. For example, the worship of Mithras, originally the Persian god of light, was a minor cult in the Greek world. After 200 BC, however, in

the culturally atomized environment of the Roman Empire—in which foreign religions were generally accepted as long as they did not interfere with the prescribed worship of the emperor—he became a major god.

A second minor cult that became more popular during the Roman Empire was that of Cybele. She was the goddess of nature and fertility, and her worship was conducted by eunuch priests who led the faithful in frenzied, bloody orgiastic rites. A third minor cult was that of Dionysus, whose worship was very meaningful to Alexander's mother, Olympias. Meanwhile, the average Greek was more interested in warding off the potential mischief of the gods than in praying to, or maintaining a personal relationship with, any of them.

Around 450 BC, especially in Athens, there emerged two countervailing temperaments or cultural movements that were to have a distinct influence on the Western world until the present.

The first was that of Greek tragic dramatists, led mainly by Aeschylus, Sophocles, and Euripides. Their collective message was chastening to the Greek character, warning against arrogance and willfulness. In a series of plays presented each year at the festival of Dionysus, these competing playwrights attempted to teach the Greeks how terrible was the punishment for disobeying the gods. They harped particularly on the trait they called hubris, or a blatant elevation of human will over that of the gods. The tragic dramatists warned the Athenians

against such arrogance: Whether it was by the anger of the gods or the hinge of fate, proud, heedless people would be cast down.

Prizes were given for the best plays, and all playwrights were in competition with one another. The subject matter of most plays originated in mythology, and much license could be taken with the story, because generally the audience was familiar with it. In most cases a chorus acted as the narrator, and the roles were played as types, the actors wearing masks that fit the types. The plays frequently dealt with human frailty and wickedness. Their protagonists were highborn citizens who suffered from one character failing or another—which Aristotle referred to as a "tragic flaw"—that proved to be their undoing. Sometimes even the gods entered into the fray and influenced the outcome one way or another. Generally, though, the hero had to prove himself better than most humans, thus representing the ideal of humanity. Because of its humanistic values, Greek drama would prove to be a lasting gift to the Western world.

A second countervailing temperament was inculcated by the philosophers Socrates, Plato, and Aristotle. Socrates taught Plato, who in turn taught Aristotle—and Aristotle taught Alexander. The philosophers' teachings were slightly different, but they all taught that the human mind could and should be used to temper the Greek bent toward passion and to focus on reason as an alternative to violence.

Socrates never put any of his teachings into writing, leaving

it to his pupils, most notably Plato, to immortalize his words—and he never had an official school, but rather spent his time walking around Athens, questioning and teaching the young (and anyone else who would listen) about religion and government. He wanted no one just to accept the opinions or beliefs of any other person, not even himself. His way of answering a question with a question, which forced the students to investigate *why* they believed what they thought they believed, or what was generally accepted information—the Socratic method—became the basis of an entire teaching mode that is practiced even today in many universities. "Know thyself" and "Nothing to excess" became catchphrases that he attempted to instill in his audience. He was forced to commit suicide after being found guilty of crimes against the state and the state religion, and of contributing to the delinquency of minors.

Plato, a follower of Socrates, was so disillusioned by Socrates' death that he went into voluntary exile. When he returned to Athens in 387 BC he established his school, the Academy, in which emphasis was placed on the sciences and philosophy. He introduced the works of Pythagoras to Greece, and taught that mathematical learning must be used to attain philosophical truths. Plato's *Dialogues* were a series of essays on various subjects, many of which attempted to justify and preserve for posterity the teachings of Socrates.

"The Apology" gives a description of Socrates' defense and his trial, in which he excoriates his detractors and expresses no regrets or apologies for his actions or beliefs. "The Crito" describes the imprisonment and death of Socrates. In this essay

Plato discusses whether a citizen is ever justified in refusing to obey the laws of the state. The best-known of these *Dialogues*, however, is probably "The Republic," in which Plato introduced the concept of a Utopian society and extolled the virtues of justice, wisdom, courage, and moderation as representative of an ideal citizen of an ideal society.

Aristotle's studies were far-reaching. At various times in his life he addressed issues of logic, philosophy, ethics, physics, biology, psychology, politics, and rhetoric. In the collection of his treatises on logic, known as the *Organon,* he describes a universal method of reasoning and the use of deductive inference, which came to be called categorical logic. Aristotle applied this system as well to biology and astronomy. In his *Ethics* he addresses issues of morality, happiness, virtue, and friendship. Aristotle defines the ingredients for happiness, which include good health, friendship, enough money, a job, and a family. If at the end of a person's life, he can say that it was composed of a balance of all these, in retrospect he can also say that he was happy.

Plato and Aristotle differed radically on what was the best form of government. Their disparate ideas are exemplified by Plato's *Republic* and Aristotle's *Politics*. Plato favored the Spartan model, which involved a king and aristocrats, a military oligarchy; Aristotle was much more liberal. Like the authors of the American Constitution, who studied him assiduously, he advocated a system of "mixed government." He thought there should be a peaceful blending of aristocrats, middle-class democrats, and peasants.

The various Greek cultural movements were in part self-correcting. They identified a moderate sense of life to countervail arrogance and hotheadedness; they upheld reason against the passions. Thereby Greek, mainly Athenian, tragic dramatists and philosophers came to be adored by the Victorian upper middle class, with its inveterate romantic idealism. The Victorians identified with ancient Greece, seeing in it a modulation between the high culture and anarchy of their own society. The Victorians looked into the Greek mirror and saw their own cultural paradoxes reflected back at themselves.

Previously Europeans had satisfied themselves with artistic models from late Hellenistic and Roman times, but now it was the Victorian British and the imperial Germans of the Second Reich who revived an appreciation of the glories of Greek literature, sculpture, and architecture of the Heroic and Classical Eras.

It was the privilege and honor of two British archaeologists and one amateur German with an avid interest in anything Trojan to make the mute stones of Greece speak in a highly dramatic fashion. What they—Thomas Bruce, the seventh earl of Elgin; Sir Arthur Evans; and Heinrich Schliemann—dug up revealed in all its glory the material remains of Greek culture and society that had provided the context for Alexander's life.

The discovery of ancient Greek art and architecture began with Lord Elgin, British ambassador to the sultan of Turkey, in the early years of the nineteenth century. Convinced that the Greeks could not protect their art—and with Turkish attempts

looming to suppress the Greek war of independence—Elgin took it upon himself to pack up the Parthenon frieze and other statuary from the Athenian Acropolis, for which these sculptures had been designed and where they were best displayed, and cart them off to London. Elgin's idea—to get the British Museum to buy the sculptures from him—was a private, nongovernmental venture in the second decade of the nineteenth century. Though he eventually succeeded—these works are known today as the Elgin Marbles—he was very disappointed in the offered price. The friezes and sculptures from the Parthenon remain at the British Museum to this day, despite ongoing efforts to have them returned to Greece.

In the 1870s a German millionaire and amateur archaeologist, who had grown up hearing about, studying, and eventually becoming obsessed by the stories of Homer, went to Greece with the intention of obtaining permission from the government of Turkey to dig for Troy. He acquired a very fine house and a Greek wife in Athens, and then set about excavating Homer's Troy, across the Hellespont in Asia Minor (Turkey). This was Heinrich Schliemann. After ten years of sloppy excavation, Schliemann discovered that there were at least seven layers to the city of Troy, which had been deserted or burned more than once and then rebuilt on the same site. He fastened on what he called Level IV as the city of Homer's *Iliad* because it was there that he discovered the alleged treasures of King Priam of Troy—mostly a set of splendid gold dishes and some elaborate jewelry. He smuggled most of his finds out of both Turkey and Greece, thus alienating the governments of both

countries, which demanded their return. He eventually donated the so-called Priam's treasure to the National Museum in Berlin and was suitably honored for doing so by the German emperor Wilhelm II. In 1945 the Red Army carted Priam's hoard off to Saint Petersburg, where it remains to this day in a Russian museum. (Archaeologists since Schliemann have demonstrated that "Priam's gold" could not possibly be attributed to the actual Priam.)

The third great discovery, this time by a British professor, Sir Arthur Evans, was made on the island of Crete just before the outbreak of World War I. Since the turn of the century Evans had been excavating the site of the huge palace of Knossos, which was destroyed in an earthquake perhaps around 1300 BC. Because the labyrinthine structure of the palace called to mind the myth of King Minos, Evans called the period of his discoveries the Minoan Age of Crete, and argued that the civilization of mainland Greece in the Heroic Age, known as the Mycenaean, corresponded roughly to that of Minoan Crete. Subsequently, after World War II, scholars revealed an identity between archaic Mycenaean and Minoan script, called Linear B, which lent credence to Evans's hypothesis.

Alexander the Great could not have known about the wonders of Minoan Crete, buried a thousand years before his time. Neither does he ever appear to have visited Athens, where the buildings and sculptures on the Acropolis had been created only a century before his lifetime. But he knew about the

glories of the Mycenaean Heroic Age: Alexander slept, we are told, with a copy of Homer's *Iliad* close at hand.

Alexander should have equally esteemed the other Homeric hero, Odysseus (Ulysses to the Romans), whose ten-year travels in the Mediterranean, described in Homer's *Odyssey*, had, in spirit, some similarities to Alexander's own wanderlust. But Alexander's mind did not run that way, being fastened instead mainly on strength, war, a shared military culture, and Achilles. He saw himself as a reincarnation of Achilles, just as Gen. George S. Patton believed that in one previous life he had been a Viking and in others had fought with Caesar—and with Alexander himself.

The fanatical nineteenth-century admirers of the Greeks, such as Elgin and Schliemann, played down the obvious existence of slavery in Greek society. Similarly, they ignored the fact that Greeks of the upper classes were often pedophiles and serial child abusers. Most Greek adult males would have regarded the body of a twelve-year-old pubescent boy as the most beautiful body image. There was plenty of physical contact between adult males and their young acolytes, who were raised and educated in their households. When the Oxford don and classicist Benjamin Jowett in the 1870s came to translate Plato's *Symposium,* which is partly about the homosexual love of boys, he bowdlerized his translation, omitting the homoerotic and pedophile qualities because they did not fit with how he wanted his audience to view the Greeks.

The Greeks, with their great accomplishments in literature, art, and philosophy, were nonetheless hard men who satisfied their desires recklessly. Slaves did their physical labor and boys gratified their sexual appetites. Alexander the Great grew up in such a society, and to a certain extent his harshness and cruelty were imposed on him by his social environment.

There were some signs that Alexander appreciated the ambience of the classical Greek cities. He was familiar with some of the Greek tragedies, which were performed in amphitheaters all over his empire. Wherever he went in Egypt and Asia, he created new Alexandrian cities, laid out in rectangles, defended by walls, and with an acropolis (temples and other public buildings) and an agora (a marketplace) in the classical mode. A few of these Alexandrian urban foundations still exist in Central Asia in skeletal form. Everywhere Alexander went, sculptures and monuments in the classical style were also his legacy, and the workshops of his empire were kept busy turning out these memorials of antiquity.

To the cities of Greece (Athens, Sparta, Corinth, and Thebes were the major ones) and to colonial Greek cities in Asia Minor, Alexander offered self-government and restored town councils where they had been replaced by oligarchs. But this was something of a facade brought on by the pragmatic exigencies of wartime. When Thebes refused to join Alexander's league of cities with himself as *hegemon* (leader), he burned it to the ground and sold its citizens into slavery.

In assessing the Victorian idealization of Greek culture, we cannot say that the tragic, restraining sensibility or the drive

to make rationality primary in human relationships captured the essence of the Greek way of life. The Greeks' greed, violence, sexual promiscuity, slavery, child abuse, and drunkenness stand in sharp contrast to the civilizing doctrines of the tragic dramatists and the philosophers.

It is probably true to say that all cultures bear the stamp of inner conflict and contradiction. But Greek culture was among those that suffered the deepest split in mind-set. To go from the masculine chauvinism of the Greek Heroic Age to the civilized morality and vaunting rationality inculcated by the playwrights and philosophers of the Classical Age is to pass from one cultural and intellectual era to another. The ascendancy of Macedonia under the rule of Alexander's father, Philip II, and the conquest of the rest of Greece, forced the combination of the Heroic Age with the civilizing influence of the philosophers and tragedians. Alexander stands out as an excellent example of this dichotomy, as he was the child of both sides of the culture—a product of violent, passionate parents and a student of that paragon of reason, Aristotle.

Alexander, who would eventually be called "the Great," was born in the kingdom of Macedonia, which comprised most of northern Greece. Culturally and intellectually Macedonia was far removed from the city-states of southern Greece, especially Athens. Structurally it was much closer to the military autocracy that prevailed in Sparta. By the time Philip came to power in 359 BC, the city-states of Thebes, Sparta, Argos, and Athens had

already achieved their eras of greatness and were ripe to be con-
quered by a strongman such as Philip. By the late 340s BC, with
the annexation of Thrace and Thessaly, Philip had made Mace-
donia a superpower, with no real challenge to its domination of
the entire peninsula. He had even been urged by an outstanding
Athenian orator, Isocrates, to unite Greece and attack Persia.
Any opposition was met with strong military might. In August
338, Philip's army faced a coalition of Thebans and Athenians,
who had little or no support from any other city-state. On the
plain of Chaeronea, Philip's phalanx defeated the combined
armies, with the Athenians alone losing one thousand dead and
two thousand prisoners.[1] Philip was now supreme in Greece.

With its abundant natural resources, including gold and sil-
ver deposits and fertile plains suitable for agriculture, Mace-
donia was a very wealthy country. Moreover, dues to the
crown and tax levies augmented the royal treasury, permit-
ting Philip to bribe people into submission when he wanted
to avoid the use of force. The king used his considerable
wealth to cement alliances and ensure the loyalty of small
cities in his territories.

Macedonia was also rich in people. The Macedonian infantry
under arms in 334 BC numbered 27,000, with ample reserves
that could be mustered in subsequent years. At the Battle
of Chaeronea, for example, Philip's army was estimated at
30,000 foot soldiers and 2,000 cavalry. In addition, numerous
allies under arms could be called on at all times.[2]

* * *

Philip, who traced his ancestry to Hercules, ruled as an autocrat, subject to few political restraints. He probably consulted a small group of intimates, but they were strictly advisory, rather than holding any real power. There were no regular assemblies, and the king was not bound by public opinion. Procedures were fluid and continually changing at Philip's decision and whim. Though there was some notion of legal precedent and tradition, there was no code of Macedonian law.

Macedonia was a wild country, socially closer to the Balkans than to Athens. The official method of public execution was stoning, but Philip used crucifixion or impalement on several occasions. The penalty for treason was death not only for the perpetrator but for all his blood relatives as well. Because of the extent of intermarriages among the upper class, this provision of the law was rarely applied, however, or the entire ruling class might have been wiped out.

Homosexuality was widespread, as was polygamy—Philip himself had seven or eight wives. Marriage was predominantly a political matter, and women had no power whatsoever. This social, geographical, and cultural interconnectedness between one era and another, and one location and another, probably goes a long way toward explaining the enigmatic behavior of Alexander the Great.

The consortium of allies brought about by Philip met at Corinth in 337 BC to declare war on Persia. For many years the Persian Empire had been in decline, and Philip believed that the time was propitious for an attack. Rebellions in Egypt and Babylon had left the Persian emperor, who had relied on

Greek mercenaries to supplement his own army, amid disorder and disarray. Philip's alliances had made recruitment by the Persians difficult if not impossible, but he kept his ultimate intentions secret, obviously waiting until there was no more resistance in Greece before he advanced into Persia. In the spring of 336 BC, a group of Macedonians crossed the Hellespont and began the subjugation of Asia Minor. It was at this critical juncture in his life that Philip was cut down by an assassin.

This was the world that Alexander inherited.

The Achaemenid Persian Empire, which became Alexander's chief antagonist and his first conquest, had been established in 539 BC by Cyrus I—the same "king of kings" (a term used for all Persian kings) who sent the Jews, after a fifty-year exile, back to Jerusalem. During the last years of Philip's reign the Persian Empire, ruled by King Ochus, had its problems. Diodorus Siculus, a Roman writer of the second half of the first century BC, described the bloody ascension of Darius to power.

> While Philip was still on the throne [of Macedonia], Ochus was king of Persia, and his rule over his subjects was brutally harsh. Ochus was detested for his callousness, and his chiliarch [commander of a thousand men] Bagoas—he was, physically, a eunuch but had a villainous and aggressive nature— did away with him by poison, through the agency

of a certain doctor. Bagoas then put the youngest of Ochus' sons, Arses, on the throne. He also did away with the new king's brothers, who were still at a very early age, so that the young man's isolation would make him more compliant to him. The young man, however, was outraged by Bagoas' lawless conduct and made it clear that he was going to punish the perpetrator of these crimes, where-upon Bagoas struck before he could implement his plans, murdering Arses, along with his children, when he had been king for two years.

The royal house was now without an heir and there was no descendant to succeed to power, and so Bagoas picked out one of the courtiers, Darius by name, and helped him gain the throne. . . . There was a curious incident involving Bagoas that is worth recording. With his usual bloodthirstiness he attempted to murder Darius with poison. Infor-mation concerning the plot reached the king, who issued an invitation to Bagoas on some pretext of sociability. He then gave him the cup and obliged him to drink the poison.

Darius was considered fit to rule because of his reputation for surpassing all Persians in courage. Once when King Artaxerxes {a former king and re-lated by blood to Darius} was at war with the Cadusians, one of the Cadusians, who was noted for

strength and courage, issued a challenge to single combat to any of the Persians willing to accept. Nobody dared take up the challenge apart from Darius, who alone faced the danger and killed the challenger, for which he was honoured by the king with sumptuous gifts and gained amongst the Persians unrivalled prominence for his courage. It was on account of this brave showing that he was considered worthy of the throne, and he took power about the time that Alexander succeeded to his kingdom on the death of Philip.[3]

He was called the "king of kings."

The last king of the Persian Empire was Alexander the Great. Alexander regarded himself not as an interloper but as a successor of the Achaemenids, replacing Darius III. Alexander was remorseless and persistent in pursuing Darius through two fierce battles and scouring the countryside intending to capture him. Though it is just possible that Alexander would have treated Darius benignly, it is more likely that he would simply have killed and supplanted the king of kings.

The Persian Empire—an area stretching from Turkey to Tajikistan—comprised numerous highly autonomous peoples of whom it demanded only tribute, a complex system of taxes and gifts. Thus the Achaemenid rulers were very wealthy, and by capturing their treasuries, Alexander made himself the richest man in the world. Though Persian wealth had been

among the reasons for Alexander's invasion of the Persian Empire, he had no idea when he started exactly how rich the king of kings might be. A description of the wealth of Darius III is given by Quintus Curtius Rufus, a Roman writer of the first century AD, who wrote the first full-length account in Latin of Alexander:

> It is a tradition among the Persians not to begin a march until after sunrise, and the day was already well advanced when the signal was given by trumpet from the king's tent. Above the tent, so that it would be visible to all, a representation of the sun gleamed in a crystal case. The order of the line of march was as follows: in front, on silver altars, was carried the fire which the Persians called sacred and eternal. Next came the Magi, singing the traditional hymn, and they were followed by 365 young men in scarlet cloaks, their number equalling the days of the year [for in fact the Persians divide the year into as many days as we do]. Then came the chariot consecrated to Jupiter, drawn by white horses, followed by a horse of extraordinary size, which the Persians called "the Sun's horse." Those driving the horses were equipped with golden whips and white robes. Not far behind were ten carts amply decorated with relief carvings in gold and silver, and these were followed by the cavalry of twelve nations of different cultures, variously armed. Next in line were the soldiers

whom the Persians called the "Immortals," some 10,000 in number. No other group were as splendidly bedecked in barbarian opulence: golden necklaces, clothes interwoven with gold, long-sleeved tunics actually studded with jewels. After a short interval came the 15,000 men known as "the king's kinsmen." This troop was dressed almost alike, its extravagance rather than its fine arms catching the eye. The column next to these comprised the so-called *Doryphoroe*, the men who usually looked after the king's wardrobe, and these preceded the royal chariot on which rode the king himself, towering above all others.

Both sides of the chariot were embossed with gold and silver representations of the gods; the yoke was studded with flashing gems and from it arose two golden images {each a cubit high} of Ninus and Belus respectively. Between these was a consecrated eagle made of gold and represented with wings outstretched.

The sumptuous attire of the king was especially remarkable. His tunic was purple, interwoven with white at the center, and his gold-embroidered cloak bore a gilded motif of hawks attacking each other with their beaks. From his gilded belt, which he wore in the style of a woman, he had slung his scimitar, its scabbard made of precious stone. His royal diadem, called a *cidaris* by the Persians, was

encircled by a blue ribbon flecked with white. [Ten thousand] spearmen carrying lances chased with silver and tipped with gold followed the king's chariot, and to the right and left he was attended by some 200 of his most noble relatives. At the end of the column came 30,000 foot-soldiers followed by 400 of the king's horses.

Next, at a distance of one stade [a unit of measurement equal to some 185 feet], came Sisygambis, the mother of Darius, drawn in a carriage, and in another came his wife. A troop of women attended the queens on horseback. Then came the fifteen so-called *armamaxae* [covered wagons] in which rode the king's children, their nurses and a herd of eunuchs (who are not at all held in contempt by these peoples). Next came the carriages of the 360 royal concubines, these also dressed in royal finery, and behind them 600 mules and 300 camels carried the king's money, with a guard of archers in attendance. After this column rode the wives of the king's relatives and friends, and hordes of camp-followers and servants. At the end, to close up the rear, were the light-armed troops with their respective leaders.[4]

The Achaemenid Empire was highly centralized in that the king of kings did whatever he wanted. The Persian ruler also had a special fondness for adding fair-skinned Greek women

to his boundless harem. And was also famous for parks that contained rare trees and wild animals he could hunt and slaughter—"Versailles with Panthers," as historian James Davidson has called it. Aside from a lavish lifestyle his wants consisted only of tribute money and adding to his vast domains, which included Turkey, Syria, Egypt, Iraq, Iran, and some lands farther east. Far from enforcing Iranization in the then-thriving cities of Asia Minor, the Persian emperor allowed the beginnings of Hellenization to occur there.

The Persian Empire was largely governed by satraps, or imperial governors, who were usually Persians, and the constituent peoples were left alone to pursue their own cultures, languages, and religions. The Persian Empire falls into the category of hydraulic despotisms of antiquity. Eighty percent of the population lived on the land, drawing sustenance from rivers and irrigation systems. The empire also comprised large urban centers numbering up to a million people each. The general populace was poor and lived in mud or sun-dried brick huts. There were temples dedicated to the gods, inhabited by a priestly caste. And above all there were three huge palaces and government centers at Babylon, Susa, and Persepolis.

The Persian Empire was a "soft" empire, resembling the British Empire of the nineteenth and early twentieth centuries. The imposition of a common English culture was far beyond the capacity or even the ambition of the British Empire's modest-size official personnel. Rulership in the British Empire varied radically. In Africa and parts of India, the

British were content with "indirect rule"—leaving government largely in the hands of native chieftains and princes. Hedonism, eroticism, and self-indulgence on the part of the elite were common characteristics of such soft empires.

The Roman Empire, in contrast, was hard-core. Only two languages—Greek in the East and Latin in the West—were recognized. Every effort was made to impose Greco-Roman culture and religion on the peoples of the Roman Empire. In spite of the failures of the communication network of the time, the Roman Empire was controlled centrally from Rome, through governors who behaved in a demanding and often rapacious manner. The imposition of the Roman lifestyle on its conquered people is why the Roman Empire has had such a far-reaching influence on the Western world until the present day.

Alexander's empire, modeled on that of his Persian predecessor, was of the soft variety, although had he been given a few more years, it might have hardened over time.

Before Alexander invaded Persia, his route of conquest took him from Tyre in Lebanon—which he captured and leveled after a long siege—to Gaza and Egypt. Along the way he encountered Jerusalem, then a city of perhaps 15,000 people. Cyrus's release of the Jews of Iraq to return to their homeland had been only partially successful; a third of them went home. The rest were comfortable as craftsmen and small merchants, and they remained in Iraq, where their descendants lived until about 1950.

Jerusalem surrendered peacefully to Alexander. The high priests came out of their city and brought him gifts. There is no indication that Alexander tried to visit the sanctuary of the Holy of Holies in the Second Temple, which was still in the course of being built with a subsidy offered by Cyrus I.

Jews were, however, slated to play a significant role in Alexandria. This was the great port, today partly under water, that Alexander founded, the only really successful Alexandria among the seven cities by that name that he established. By the first century AD the Egyptian Alexandria had a population of 750,000, of whom at least a third were Jews. Jewish merchants and scholars enlivened the city. They were a Greek-speaking minority; few of them could read Hebrew. Around 200 BC the Hebrew Bible was translated into a Greek version called the Septuagint, after the seventy sages who supposedly worked on it. This was the biblical text used by the Greek Jews of Alexandria.

The greatest scholar among these Jews of Alexandria was Rabbi Philo, whom the Romans called Philo Judaeus. Philo, who lived in the middle decades of the first century AD, attempted a synthesis of Judaism and Platonic philosophy. He was what we today would call a Reform Jew, preaching and writing in Hellenistic Greek. (It is not known whether he even read Hebrew.)

The Jewish community of Alexandria was originally drawn from all over the eastern Mediterranean, and in many instances those Jews were Greek-speaking when they arrived in

Alexandria. Alexander would have loved the Alexandrian Jews.

Alexandria remained the great center of Reform Judaism until around AD 300, when the Jewish community there was reduced and impoverished by Christian pogroms. After that only Orthodox Talmudic Judaism prevailed in the Jewish world. Reform Judaism did not reappear in Germany and the United States until the mid-nineteenth century.

If Alexander aimed at Hellenization—and he had that vaguely in mind—it was the Jews of Alexandria who best exemplified the process. They spoke Greek as their daily language; they translated the Hebrew Bible into Greek; their leading scholar, Rabbi Philo, sought a synthesis between Judaism and Platonism.

Rabbi Philo envisaged a monotheistic God whose light shone upon mankind, God's spirit a fountain immersing the world in light. Here is the origin of what became Jewish mysticism, the kabbalah, in Western Europe in the thirteenth century. Because of Philo's affinity with Christian mysticism, the early church fathers preserved a dozen volumes of his works. While the writings of Saint Paul (Rabbi Saul of Tarsus), Philo's contemporary, are known to us from only half a dozen meager letters to Christian communities, Philo's elaborate writings are readily available today.

No similar cultural blending occurred in Persia, in spite of such far-fetched stratagems as Alexander's marrying his generals to Persian noblewomen. When Alexander died, nearly all

of them promptly abandoned their Persian wives. It was the Jews of Alexandria who flourished by engaging in long-distance trade to Asia Minor, Arabia, and as far away as India. These Jews had thoroughly absorbed Hellenistic culture. They too had their *gymnasia*, where they bathed, modestly clothed, in preparation for Philo's Sabbath sermons.

More than anyone else, the Alexandrian Jews achieved a union of Greek language and culture and Judaism, but by AD 400 it had all vanished under Christian persecution. (The Alexandrian Jewish community partly revived in the twelfth century under Muslim rule, this time under the leadership of an Orthodox rabbi, Maimonides.)

Writing in the Roman Empire in the early second century AD, the Greek historian and biographer Plutarch, in his very popular book *Parallel Lives*, tried to compare Alexander the Great and Julius Caesar, who lived three hundred years later. In the beginning of his book, Plutarch says of Alexander:

> It being my purpose to write the lives of Alexander the king, and of Caesar, by whom Pompey was destroyed, the multitude of their great actions affords so large a field that I were to blame if I should not by way of apology forewarn my reader that I have chosen rather to epitomise the most celebrated parts of their story, than to insist at large on every particular circumstance of it. It must be borne in mind that my design is not to write histories, but lives. And the most glorious exploits do not always

furnish us with the clearest discoveries of virtue or vice in men; sometimes a matter of less moment, an expression or a jest, informs us better of their characters and inclinations, than the most famous sieges, the greatest armaments, or the bloodiest battles whatsoever. Therefore as portrait-painters are more exact in the lines and features of the face, in which the character is seen, than in the other parts of the body, so I must be allowed to give my more particular attention to the marks and indications of the souls of men, and while I endeavour by these to portray their lives, may be free to leave more weighty matters and great battles to be treated of by others.[5]

The trajectory of their lives was completely different, however. Caesar was a politician who incidentally acquired renown by fighting as a very effective general in Gaul (France) and then used his military fame to intervene in and dominate Roman politics. Alexander inherited a throne and a superb army and did not need to meddle in politics as Caesar did; he aimed instead at pure military glory. He was the unique hero of the ancient world. There was no one else in antiquity whose life followed quite the same path as Alexander's.

Caesar was essentially a very clever and ambitious politician who pursued a military career, and became a military hero only because it suited his political aspirations. To Alexander, on the other hand, warfare was a primal life force, and he

spent nearly all his adult life on the battlefield. Not only did he exult in war, but he also carried out innovations in battlefield tactics and sought and gained the devotion of his military companions. Caesar was more detached and conscious of a separation between his political and military careers. When Caesar crossed the Rubicon, he knew the political consequences were going to be much more significant than the military ones. Alexander experienced no such conflict between politics and his wars.

Alexander emulated Achilles, the hero of the Trojan War, whom he considered an ancestor on his mother's side. Symbolically, his first stop toward conquest was in Troy. Historian Peter Green describes the landing:

> The king's first act on landing was to set up another altar, to Athena, Heracles, and Zeus . . . and to pray that "these territories might accept him as king of their own free will, without constraint." Then he set off on his pilgrimage to Ilium. . . . He was welcomed by a committee of local Greeks. . . . They presented him with ceremonial gold wreaths. Alexander then offered sacrifice at the tombs of Ajax and Achilles. . . . He made lavish sacrifice to Athena, and dedicated his own armour at the goddess's altar. In exchange he received a shield and panoply of guaranteed Trojan vintage, with which he armed himself for his first major engagement on Asiatic soil, at the Granicus River. However, they

got rather badly knocked about during the fighting, and thereafter Alexander merely had them carried into battle before him by a squire.[6]

He proclaimed that he was the product of both Greece and Troy, and the worthy heir of both Achilles and Priam, implying that this conquest was his by right. Alexander was a man dedicated to war.

TWO

Who Was Alexander?

A LEXANDER THE Great, believed by many to be
the mightiest general of antiquity, was born in July, 356 BC, of
the marriage between Philip II of Macedon and his third
wife, the Albanian princess Olympias. It is unclear exactly
how they met or when they married, but it is known that
the marriage was a stormy one. Philip was at the peak of his
political powers when they married and when Alexander was
conceived. The day Alexander was born, his father had just
taken the town of Potidaea. Philip received three messages
simultaneously—one of his generals had just overthrown the
Illyrians, his racehorse had won at the Olympic games, and his
wife had given birth to a son. The soothsayers assured him

that a child born on the same day as two other such successful events would be invincible.

On her father's side, Olympias traced her ancestry back to Achilles, and on her mother's she traced her family to Helen of Troy. She belonged to a strange cult of snake worshippers, and she probably kept and sometimes slept with pet snakes. This snake cult was related to the orgiastic worship of Dionysus and encouraged its devotees to engage in frenzied rituals. The queen would pull large snakes out of ivy or baskets and encourage the other women to coil them around their bodies. The worship of Dionysus had long been wild and uninhibited, involving animal sacrifices and drinking of the blood. In ancient times even human sacrifices took place. Philip seemed to be repelled by the fanatic zeal with which Olympias led other women in this worship, but whatever his reluctance to sanction such a religion, the couple managed to cohabit long enough to produce a son.

Philip had other wives, but for a long time Olympias was his principal one. Wild and unprincipled in many respects, she still managed to take an interest in her child's education. She brought two tutors, Lysimachus and Leonidas, from her own family to Macedonia to teach and train the young prince. The tie with Lysimachus continued into Alexander's adulthood; Leonidas, on the other hand, was very austere, forcing Alexander to satisfy himself with nothing luxurious or excessive. His education, which emphasized doing without luxuries, even necessities, stood Alexander well in his later years of deprivation, when he was traveling through the deserts in the East.

In the last three years of Philip's reign, when Alexander was in his teens, Olympias's sole ambition was to ensure the throne for her son. Alexander always remained fiercely loyal to his mother, faithfully sending her long letters after his ascension to power, reporting on his journeys and wars. These letters—except for a handful of fragments, possibly forged—have not been found and none of Olympias's letters back to Alexander have been discovered either, even though Alexander maintained a good secretary who kept a daily royal journal of his activities.

It is curious that in the last year of his life, after he ceased his Asian campaign and reestablished himself in Persia, Alexander did not send for his mother. Indeed, after he crossed the Hellespont into Asia Minor—begining a decade-long separation—mother and son never met face-to-face again. All indications are that Alexander loved his mother deeply but did not want to be in her powerful, demanding presence. Sending letters to Olympias would suffice. Alexander asserted his own identity.

Alexander's relations with his formidable and successful father were also tense. Philip conquered much of the Greek peninsula but left it to his son to organize. Philip was cautious in dealing with the noisy and resourceful cities of southern Greece. He did not try to conquer them, except for Thebes, which lay halfway down the Greek peninsula and rebelled actively against him.

Justin, a Roman writer of the late second or early third century AD and author of a life of Philip, drew a sharp distinction between Philip and Alexander:

Philip was succeeded by his son Alexander who surpassed his father both in good qualities and bad. Each had his own method of gaining victory, Alexander making war openly and Philip using trickery; the latter took pleasure in duping the enemy, the former in putting them to flight in the open. Philip was the more prudent strategist, Alexander had the greater vision. The father could hide, and sometimes even suppress, his anger; when Alexander's had flared up, his retaliation could be neither delayed nor kept in check. Both were excessively fond of drink, but intoxication brought out different shortcomings. It was the father's habit to rush straight at the enemy from the dinner-party, engage him in combat and recklessly expose himself to danger; Alexander's violence was directed not against the enemy but against his own comrades. As a result Philip was often brought back from his battles wounded while the other often left a dinner with his friends' blood on his hands. Philip was unwilling to rule along with his friends; Alexander exercised his rule over his. The father preferred to be loved, the son to be feared. They had a comparable interest in literature. The father had greater shrewdness, the son was truer to his word. Philip was more restrained in his language and discourse, Alexander in his actions. When it came to showing mercy to the defeated,

the son was temperamentally more amenable and more magnanimous. The father was more disposed to thrift, the son to extravagance. With such qualities did the father lay the basis for a worldwide empire and the son bring to completion the glorious enterprise.[1]

Philip was satisfied not to try to conquer Athens, Sparta, and Corinth. He formed them into a league with himself as *hegemon* (similar to today's chairman of the board or CEO). In Athens the orator Demosthenes so raged against Philip and forecast the threat he posed to the Greek city-states if he was not stopped (like Churchill on Hitler in the 1930s) that his speeches are a synecdoche for opposition to a tyrant. These orations are called philippics, the same term used later for the orations by Cicero against Mark Antony. (The term is still a synonym for speeches of rage and condemnation.) Alexander eventually succeeded in getting Demosthenes exiled from Athens; Mark Antony had Cicero killed.

Though Alexander was carefully trained and educated in the humanities and sciences, from the age of five he was meant to be a highly skilled soldier. He had an affinity for diplomacy, and by the time he was fifteen, he was engaging Greek ambassadors in discussions. He had a special inclination to be a horseman and is said to have personally broken in his horse Bucephelus, in whose saddle he rode into battle for the next twenty years until the animal died.

The story goes that in the Balkans King Philip had acquired

a very handsome horse of a special, elegant breed, but Philip and his grooms could not break the horse. It stood taller than the common run of runty Macedonian horses, and it boasted a proud mane and shimmering brown coat.

Philip and his grooms were about to give up on the Balkan horse as incapable of ever being broken in when Alexander, who was there, remarked that they were losing a wonderful horse simply because they were too inexperienced and too spineless to handle him. Initially Philip remained silent, but after Alexander repeated his comment and became visibly upset, Philip asked Alexander if his criticism of his elders was due to his knowing more than his elders, to which Alexander replied that he could at least handle *this* horse better than they. His father then asked his son what the consequence of his impulsiveness would be, were he to not succeed in handling the horse. His answer, which was the promise to pay the price of the horse, resulted in much laughter. After the financial terms between father and son were settled, Alexander quickly ran toward the horse. He did not immediately mount the horse. Earlier, he had noticed that the horse was greatly bothered by the sight of its own shadow, and so after he took the reins, he turned the horse toward the sun. For a short while, he ran beside it, and patted it in order to calm its panting. Then, after gently setting aside his cloak, he quickly and firmly mounted the horse, using the reins to put pressure on the bit without hurting its mouth. Once Alexander felt comfortable that the horse had dropped its menacing demeanor and was eager to gallop, he gave it some rein and urged it on, using a firmer voice and kick of his foot.

Silence fell over the crowd. But when Alexander returned truly pleased with himself, he was welcomed with cheers and applause. Philip was said to have burst into tears of joy. After Alexander dismounted, Philip kissed his head and said to him, "Son, look for a kingdom that matches your size. Macedonia has not enough space for you." Alexander was about twelve years old when this occurred.[2]

So the oft-told story goes. Alexander called the horse Bucephalus, and the two were devoted to each other. He loved that horse and for twenty years, until Bucephalus died on the border between Afghanistan and Pakistan, Alexander rode Bucephalus into battle and would ride no other until the aged steed died. For Alexander the horse was much more than an instrument. After Bucephalus's death, Alexander founded a city on the Hydaspes River and called it Bucephala in honor of his loyal mount.

During the earlier years, Bucephalus accompanied Alexander during many of his ordeals and dangers. Only the king rode Bucephalus, as he refused all others to attempt to mount him. He was a large horse with a noble spirit, and his distinguishing characteristic was the brand of an ox-head, for which he was given the name Bucephalus. Another story claims that, though black, he had on his head a white colored mark that resembled most of all an ox-head.[3]

The horse never flinched from battle, proudly carrying Alexander into the middle of the fray. There is a contemporary wall painting showing Alexander and Bucephalus encountering the Persian emperor Darius III with his scythed chariot.

Alexander on horseback hacks away at the Persian soldiers, and his army prevails over the Persian emperor, who is driven from the field. It is said that Alexander and Darius met face-to-face, and proud Bucephalus helped Alexander to triumph.

When Alexander was a preadolescent, Philip chose the philosopher Aristotle as his tutor. Though Aristotle had not yet entered into his stage of philosophical writings, he was nonetheless interested in a wide variety of subjects. Philip had maintained a long-standing correspondence with Plato, and when he needed a tutor for his son, he turned to Plato for advice. Among Plato's students, the job of teaching the young Alexander was much coveted—testimony to Philip's increasing influence—and Aristotle was chosen. It is not known exactly how long the student-teacher relationship lasted or what Aristotle and Alexander discussed, but what is known is that the years they spent together had long-lasting results. Robin Lane Fox gives us some information on this subject:

> Whether briefly or not, Alexander spent these school hours with one of the most tireless and wide-ranging minds which has ever lived. Nowadays Aristotle is remembered as a philosopher, but apart from his philosophical works he also wrote books on the constitutions of 158 different states, edited a list of the victors in the games at Delphi, discussed music and medicine, astronomy, magnets, and optics, made notes on Homer, analysed rhetoric, outlined the

forms of poetry, considered the irrational sides of man's nature, set zoology on a properly experimental course in a compendious series of masterpieces whose facts become art through the love of a rare observer of nature; he was intrigued by bees and he began the study of embryology, although the dissection of human corpses was forbidden and his only opportunity was to procure and examine an aborted fetus. The contact between Greece's greatest brain and her greatest conqueror is irresistible, and their mutual influence has occupied the imagination ever since.[4]

Aristotle felt that political science was wasted on the young because they had no experience of life and still followed their emotions. This may be a "sour grapes" feeling, since there is very little evidence that Aristotle influenced Alexander's politics at all. Once the tutoring was accomplished and Alexander was on his own, they met infrequently, if at all. There is some evidence of a correspondence, but there was a falling-out in later years. Alexander had hired Aristotle's nephew Callisthenes as his court historian. Callisthenes accompanied the king on his conquests and wrote about him in highly flattering terms—a situation that lasted until 327 BC, when Alexander had Callisthenes executed because he had become too open with his criticisms of the king and had joined a conspiracy to unseat Alexander. Even though Aristotle described his nephew as a blockhead to involve himself in such a plot, the

execution had a decided dampening effect on Aristotle's relationship with Alexander.

But when politics was not an issue, many of Alexander's interests during his adult life show a definite effect of the old philosopher:

> He [Alexander] prescribed cures for snakebite to his friends; he suggested that a new strain of cattle should be shipped from India to Macedonia; he shared his father's interest in drainage and irrigation and the reclaiming of waste land; his surveyors paced out the roads in Asia, and his fleet was detailed to explore the Caspian Sea and the Indian ocean; his treasurer experimented with European plants in a Babylonian garden, and thanks to the expedition's findings, Aristotle's most intelligent pupil could include the banyan, the cinnamon and a bush of myrrh in books which mark the beginnings of botany. Alexander was more than a man of ambition and toughness; he had the wide armory of interests of a man of curiosity, and in the days at Mieza there had been matter enough to arouse them. "The only philosopher," a friend referred to him politely, "whom I have ever seen in arms."[5]

No description of Alexander's early life would be complete without some mention of his friend Hephaestion. Likely he

was also a student of Aristotle's in the mini-school Aristotle had established at Mieza. Fox comments:

> Hephaistion was the man whom Alexander loved, and for the rest of their lives their relationship remained as intimate as it is now irrecoverable: Alexander was only defeated once, the Cynic philosophers said long after his death, and that was by Hephaistion's thighs. . . . Philip had been away on too many campaigns to devote much time in person to his son and it is not always fanciful to explain the homosexuality of Greek young men as a son's need to replace an absent or indifferent father with an older lover. Hephaistion's age is not known [but] he may have been the older of the two, like the Homeric hero with whom contemporaries compared him, an older Patroclus to Alexander's Achilles.[6]

So it was for most Greeks of the upper classes and many Macedonians, too. It was a homoerotic world wherein gay lovers caught each other's eyes.

The only anomaly in the case of Alexander and Hephaestion was that the two lovers were of approximately the same age. Most aristocratic Greeks preferred young boys of around eleven or twelve. They adopted and educated these *ephebes*, training them in music and oratory. Each Greek aristocrat had his favorite boy, but Alexander was different. Though he had plenty of *ephebes*, Hephaestion was his preferred lover.

Hephaestion was a military man and a general of at least the second rank. Alexander often dispatched him to deal with military matters, sometimes far away, but the two lovers always remained loyal to each other. They were bound by more than just sex.

Alexander must have viewed Hephaestion as almost an alter ego. On one occasion in Darius's court, Darius's mother confused the two men, and apparently believing that the taller and more aristocratic-looking of the two was Alexander, addressed Hephaestion as Alexander. When her error was pointed out to her, she was extremely embarrassed and apologized profusely. Alexander responded, "Your confusion over the name is unimportant, for this man is also Alexander."[7]

When Alexander's relationship with Hephaestion ended after two decades, owing to the latter's death, Alexander grieved deeply. Two writers of antiquity describe Alexander's actions after Hephaestion's death. Aelian (a Roman author of the late second and early third centuries AD, who wrote in Greek) says that Alexander hurled arms onto the funeral pyre, melting down gold and silver and burning expensive clothing along with the body. He sheared off his hair, emulating Achilles' grief at the death of his friend Patroclus. According to Arrian (a Greek from Bithynia who became a Roman citizen during the reign of Hadrian), he spent all day and all night prostrate beside the corpse, and others said he hanged the doctor who attended his friend for giving him the wrong medicine.[8] Alexander planned to build a huge monument to his friend and lover, a project that was scrapped when he himself died.

The violence of his grief over Hephaestion's death possibly contributed to Alexander's own premature death.

Why were the Greeks bisexual, with a strong proclivity to homosexuality, preferring usually boys and sometimes cohabiting with other adult males? One could make the argument that homosexuality was a traditional, long-standing condition of human males, practiced in antiquity not only by the Greeks but also by the Romans. There was no social stigma attached to the homosexual relationship. As long as the man did his familial duty and begot children, he was left alone to pursue whatever extramarital relationships he wanted. There was no AIDS in those days, and many Greek men viewed their wives only as breeding sows. It was only around AD 400, with the triumph of the Christian Church, that a revolution in gender relationships occurred.

The Christian bishops and priests wanted to stress the unit of the intergendered family and community. They wanted also to give an enhanced dignity to women, hitherto so badly treated in the Greco-Roman world, because women made up more than half of the membership of the church. Furthermore, at a time of drastically declining population in the early Middle Ages, the bishops and priests sought to foster heterosexual copulation.

Another way of looking at Greek homosexuality is to see it as following from the rigorous training in military life, which in turn fostered gay relationships. As is seen in the populations of jails today, men in close proximity to other men, with little

recourse to female company, will frequently seek out homosexual relationships.

The impact of homosexuality on the birthrate in some societies was drastic. In Sparta in the fourth century BC the personnel of the army declined from 10,000 to 1,000 available soldiers. Homosexuality was responsible for at least part of this decline. In sixteenth-century Persia, where homosexuality was also increasingly practiced, there was a sharp decline in population.

A prominent and pioneering biographer of Alexander, W. W. Tarn, while denying that Alexander was homosexual, said that he loved no woman except his "terrible mother," Olympias. Alexander's relationship with his father and mother can be understood only in Freudian terms. Tarn never met Freud or came under his influence; thus he did not have an opportunity to understand the full dimensions of Alexander's personality. This attitude was, however, very common among British academics during and after World War I: They fled from psychoanalytic models.

Philip trusted Alexander to the extent of making him regent in his absence during the Byzantine campaign. While his father was away, a rebellion broke out in the north, and Alexander (then only sixteen) marched north to Maedi (a wild region of modern-day Bulgaria), conquered the city, and made it into a new place he called Alexandropolis, the first of many cities he would name after himself. Having possession of the Macedonian Great Seal gave him the right to do this, but it

also indicates that his burgeoning ambition might pose a threat to his father. Philip was still vigorous and in the prime of his life. Nevertheless, he wrote to Alexander regularly, giving advice and occasional admonitions if he thought his son was doing something wrong.

In the last two years of Philip's life, however, Alexander, the presumptive heir to the throne, fell out of favor. The causes of this are complicated and open to conjecture. Philip, seeming to give new meaning to the adage "There's no fool like an old fool," fell madly in love with a much younger woman, Cleopatra. There had never been any hostilities surrounding his taking of other wives, but this time Philip repudiated Olympias on charges of adultery and implied that Alexander was illegitimate. The wedding feast was not a happy occasion for Alexander and Olympias. Green describes the confrontation:

> When Alexander walked in, and took the place of honor which was his by right—opposite his father—he said to Philip: "When my mother remarries I'll invite *you* to her *wedding*," not a remark calculated to improve anyone's temper. During the evening, in true Macedonian fashion, a great deal of wine was drunk. At last Attalus rose, swaying, and proposed a toast, in which he "called upon the Macedonians to ask of the gods that from Philip and Cleopatra there might be born *a legitimate successor to the kingdom.*" The truth was finally out, and

made public in a way which no one—least of all Alexander—could ignore.

Infuriated, the crown prince sprang to his feet. "Are you calling me a bastard?" he shouted, and flung his goblet in Attalus' face. Attalus retaliated in kind. Philip, more drunk than either of them, drew his sword and lurched forward, bent on cutting down not Attalus (who had, after all, insulted his son and heir) but Alexander himself—a revealing detail. However, the drink he had taken, combined with his lame leg, made Philip trip over a stool and crash headlong to the floor. "That, gentlemen," said Alexander, with icy contempt, "is the man who's been preparing to cross from Europe into Asia—and he can't even make it from one couch to the next!" Each of them, in that moment of crisis, had revealed what lay uppermost in his mind. Alexander thereupon flung out into the night, and by next morning both he and Olympias were over the frontier."[9]

Since Philip had raised Alexander to be his heir, followed his training and education closely, and appointed him regent in his absence, it is curious that he would antagonize Alexander at this point in his life. It has never been proved conclusively that Alexander wanted to usurp his father's throne, although his mother had always encouraged him to be his own man and had always taken his side in battles between father and son. There was a natural rivalry, and now that Philip was getting ready to

invade the Persian Empire, Alexander felt that his father would get the glory that should have been his. After all, he was the reincarnation of Achilles. Perhaps, as with many royal heirs, Alexander was openly showing too much impatience about gaining the throne from the long-lived Philip.

When the new queen, Cleopatra, was delivered of her child some months later, however, it was a girl. Philip must have believed that he could not leave the country without an heir in place and with Alexander dangerous and discontented in exile. On her part Olympias was fomenting rebellion at her brother's court in Epirus, so Philip, always a pragmatist, recalled Alexander from his exile and reinstated him as his heir, but by then Cleopatra was pregnant a second time.

Receiving the news that his brother-in-law in Epirus was planning an invasion of Macedonia, Philip, in his usual fashion, proposed a marriage between Olympias's brother and her daughter, also named Cleopatra. Although this was an incestuous relationship, it was approved nevertheless, and the wedding was set to take place in June.

Shortly before the wedding, Philip's wife, Cleopatra, again gave birth, this time to a son. If Olympias and Alexander were going to do anything about the succession, now was the time.

Philip and his court were celebrating the wedding of one of his daughters when he was attacked with a short sword by a minor courtier. Green describes the assassination:

> Philip himself appeared, clad in a white ceremonial cloak, and walking alone between the two

Alexanders—his son and his new son-in-law. . . . As he paused by the entrance to the arena a young man—a member of the Bodyguard itself—drew a short broad-bladed . . . sword from beneath his cloak, darted forward, and thrust it through Philip's ribs up to the hilt, killing him instantly. He then made off in the direction of the city-gate, where he had horses waiting. There was a second's stunned silence. Then a group of young Macedonian noblemen hurried after the assassin. He caught his foot in a vine-root, tripped, and fell. As he was scrambling up his pursuers overtook him, and ran him through with their javelins.[10]

Philip's assassin was a man named Pausanias, who according to some sources had been Philip's lover several years before. Philip had broken off the relationship and had turned to another lover. There was a great scandal in the court about this sordid affair, and Attalus, whose niece Philip had married, decided to take matters into his own hands. He invited Pausanias to a banquet, got him drunk, and then he and his guests gang-raped the young man. Pausanias went to Philip asking for his help, but because of the alliance with Attalus, Philip was slow to do anything about it, so the brooding courtier exacted his revenge by killing the king. The other explanation is that the murder was arranged by Philip's wife—Alexander's mother, Olympias—and by Alexander himself because they

were concerned about whether Alexander would actually gain the throne before Philip disinherited him.

The two scenarios of Philip's death—assassination by an aggrieved ex-lover and complicity by Olympias and Alexander in a plot to kill him—are not mutually exclusive. The sexually abused courtier who did the terrible deed could have been put up to it by Olympias and Alexander. The three courtiers who assaulted Pausanias were friends of Alexander's and could easily have been enticed to kill Philip, through bribes of either money or position in Alexander's new government. That they were responsible for Pausanias's death gives credence to the idea that they put him up to the murder and then killed him so that he could not talk.

Alexander's relationship with his father and mother involved the classic paradigm of an Oedipus complex. His father was a bold, aggressive, successful, and sexy man. His mother was equally bold, aggressive, and sexy, and she doted on her son. Lest it be thought that Freud's Oedipus complex was unknown in the ancient world, Sophocles sketched the essential Oedipal paradigm in his play *Oedipus the King,* from which tragedy Freud derived both the paradigm and the appellation.

It is true that Sophocles' King Oedipus inadvertently and unknowingly killed his father and married his mother. But given the push of unconscious drives, the difference between Alexander and Oedipus is small. It was hubris, in this instance

the arrogance of negligence, that, according to Sophocles, drove the king to kill his father and marry his mother.

In Alexander's case he came to fear and hate his father and possibly became involved in a plot to kill him. He was so sexually attracted to his mother that he fled from her presence. Beneath Sophocles' depiction of reckless hubris on the part of Oedipus, there lies a sexual triangle embedded in the unconscious, and that is the way the drama is often presented today.

An ambience of thick sexuality, and ultimately of patricide, certainly surrounds this family—Philip, Olympias, and Alexander. It pressed explosively upon them.

We can only imagine the psychological pressures the young Alexander was under. He had a very strong father who raised and educated him to be heir to the throne, then appeared to reject him, at least temporarily. He had a mother who cohabited with snakes and then suffocated her son with love. Killing his father and making love to his mother were probably images that flickered through his conscious mind and were more prevalent deep in his unconscious.

Alexander rid himself of both his father and his mother and thereby resolved his Oedipal problem. Only then was he— independent of his parents' oppressive shadows—able to indulge his reckless bravery and achieve the satisfactions of world conquest.

Alexander's sex life and sexual proclivities have always been the subject of much conjecture. From one era to another his homosexual behavior has been alternately ignored and

accepted. What should be remembered again is that homosexual liaisons were common, even accepted, in ancient Greece and Rome.

Plutarch relates an interesting anecdote about Alexander's sexual attitudes:

> Philoxenus, governor of the coastal areas, informed Alexander by letter that a certain Theodorus of Tarentum was with him, and that the man had two exceedingly good-looking boys to sell. He asked Alexander if he wanted to buy the boys. This angered the king, who time and again cried out to his friends asking them what moral failing Philoxenus had ever seen in him to make him waste his time procuring such vile creatures. In a letter to Philoxenus he roundly berated him and ordered him to tell Theodorus to go to hell along with his wares. Alexander also came down heavily on Hagnon who, with youthful exuberance, had told him in a letter that he wanted to purchase Crobylus, famed in Corinth for his good looks, and bring him to the king.
>
> When he was apprised that the Macedonians Damon and Timotheus, who were serving under Parmenion, had debauched the women of some mercenaries, the king sent written orders to Parmenion that, if the men were found guilty, he should punish them with execution as being wild animals

born to destroy human beings. In this letter he also has this to say about himself (and I quote): "In my case it would be found that, so far from looking upon the wife of Darius or wishing to look upon her, I have not even permitted people to talk of her beauty." And he would state that his awareness of his mortality arose most from sleeping and the sexual act, as if to say that tiredness and pleasure derived from the same weakness in nature.[11]

Although the army noticed his sexual preference for males, Alexander was undoubtedly bisexual. He married four or five wives and had several favorite concubines; among these was a certain Greek whore named Thaïs. The prologue to most Greek celebrations was a drunken brawl featuring heavily intoxicated males supplemented by a handful of high-class prostitutes called *hetairae*. A *hetaira* had to be young, fifteen to twenty-five years of age, and preferably clever and well educated. She was supposed to be able to recite Homer and some lines from Greek tragedies. These were the circumstances in which Alexander encountered Thaïs, a Greek courtesan. They were attracted to each other when they met in the Persian emperor's palace in Persepolis, which Alexander had occupied and where he sat on a throne with a diadem on his head.

Late at night in the middle of a drunken brawl, Thaïs grabbed a torch and set fire to the Persian emperor's palace. It had cedar ceilings, and the fire spread rapidly. Alexander, as usual, was drunk and joined Thaïs in torching the palace,

which was totally destroyed. The next morning, when he sobered up, Alexander expressed remorse that the palace was gone, but by then it was too late. The palace at Persepolis was never rebuilt but was left for modern archaeologists to disinter.

Alexander had another relationship with a concubine by whom he had a child, a daughter for whom he took little responsibility. But his generals told him it was time to get married so that he could produce a legitimate son and successor. In 326 BC he married a Bactrian (Uzbekistani) princess, Roxane, reputed to be the most beautiful woman in the empire—but legends always say that about queens. Plutarch describes the episode in this way:

> And then there was the matter of Roxane. His actions were motivated by passion—he had noted her beautiful and comely looks when he saw her participating in a dance during the after-dinner drinking—but the situation was not disadvantageous to what he had in prospect. The barbarians were heartened by the partnership this marriage represented, and they were very fond of Alexander because he showed exceptional self-control and would not presume to touch the only woman who captured his heart unless the law permitted it.[12]

After their marriage Alexander had little to do with Roxane, who did not become pregnant until after the death of Hephaestion. Just one act of copulation was sufficient, since

Roxane had been acquired only for her fertility, meant to assure Alexander's generals of the continuation of his dynasty. When Alexander died in 323, Roxane was pregnant. She then delivered a son who appeared to assure the future of the Macedonian line.

Such was not to be, however. Cassander, who emerged as the strongman in Macedonia after Alexander's death, had Roxane, her infant son, and for good measure Alexander's mother, Olympias, all killed. Cassander was not related to Philip; he was, in effect, a usurper. Nonetheless his dynasty lasted until 164 BC, when Macedonia was conquered by the Romans.

Alexander had two other wives: the eldest daughter of the Persian emperor Darius III, and the youngest daughter of Darius's immediate predecessor. These marriages occurred at Susa near Babylon in 325 BC, when Alexander was trying to persuade his generals to take Persian wives. He set an example for them by marrying the daughters of the late emperors.

Before the weddings Alexander would not let himself gaze upon the wife, daughter, and granddaughter of the emperor. He sent someone else to deal with them and inform them after his second battle with Darius III. When the Persian women were captured, Alexander saw to it that they would be treated with the respect, dignity, and comfort suitable to their rank. Presumably Alexander would not look upon these beautiful women because he could not avoid the temptation to ravish them, more for political than sexual reasons. Whether Alexander's

marriages to the daughters of the Persian emperors were consummated is unknown. He certainly had little enough to do with them after the marriages at Susa. (While Alexander's treatment of women was not exemplary, it was probably a little better than that of most Greeks of the upper class in his time.)

There is an ancient story that Alexander was visited by the queen of the Amazons (who—if she actually existed at all—seems to have come from the Crimea). She wanted to sleep with the king for thirteen straight nights so that he would impregnate her. Whether she did or not is unknown, but ancient biographers tell stories similar to the following:

> On the border of Hyrcania . . . lived a tribe of Amazons. They inhabited the plains of Themiscyra in the area of the river Thermodon, and their queen, Thalestris, held sway over all those between the Caucasus and the river Phasis. Passionately eager to meet Alexander, she journeyed from her realm and when she was not far off she sent messengers ahead to announce that a queen had come who was longing to see him and make his acquaintance. Granted an immediate audience, she ordered her company to halt while she went forward attended by 300 women: as soon as she caught sight of the king she leaped unaided from her horse, carrying two spears in her right hand. The dress of Amazons does not entirely

cover the body: the left side is bare to the breast but clothed beyond that, while the skirt of the garment, which is gathered into a knot, stops short of the knee. One breast is kept whole for feeding children of female sex and the right is cauterized to facilitate bending the bow and handling weapons.

Thalestris looked at the king, no sign of fear on her face. Her eyes surveyed a physique that in no way matched his illustrious record—for all barbarians have respect for physical presence, believing that only those on whom nature has thought fit to confer extraordinary appearance are capable of great achievements. When asked if she had a request to make she unhesitatingly declared that she had come in order to share children with the king, since she was a fitting person on whom to beget heirs for his empire. A child of female sex she would keep, she said, but a male she would give to his father. Alexander asked if Thalestris wished to accompany him on his campaigns, but she declined on the grounds that she had left her kingdom unprotected, and she kept asking him not to let her leave disappointed in her hopes. The woman's enthusiasm for sex was keener than Alexander's and she pressed him to stop there for a few days. Thirteen days were devoted to serving her passion, after which Thalestris headed for her kingdom and Alexander for Parthiene.[13]

Another common belief concerning Alexander's excesses concerns alcohol. Several sources claim that he was an alcoholic, but whether he drank more than others of his day is uncertain. Alexander was given to drunken brawls while carousing with his generals. In the last two or three years of his life, however, days went by during which he did nothing else but drink. Some writers attribute his death to drinking—indeed, to what today we would call alcohol poisoning. There being no hard liquor in the ancient world, wine was his drink, beer being too plebeian for his tastes. (If he drank the resinated wine common in Greece today, he would be imbibing approximately 10 percent alcohol. It was noted that Alexander did not water his wine as was commonly done in ancient Greece.) According to Aelian, "The greatest drinkers, so they say, were Xenagoras, the Rhodian, whom they called 'The Jar,' the boxer Heraclides, and Proteas, son of Lanice, who was brought up with King Alexander. In fact, Alexander himself is said to have exceeded all men in his drinking."[14]

Alexander was very pious—or superstitious, depending on one's point of view. He was forever offering sacrifices to propitiate or thank the gods. To offer a sacrifice meant providing a live lamb or chicken (or goat or cow) to temple officials who would slaughter, roast or barbecue, and eat the animal. This was how priests in temples to the gods received their supply of fresh meat. Of course monetary and other gifts to temples would also be welcome, but offering sacrifice was a religious ritual, and Alexander took pains to observe it.

Every time he crossed a large river on rafts, he offered sacrifice on reaching the other shore. Since the gods were an ever-expanding pantheon, he offered sacrifice at the shrines of Persian and Egyptian gods as well as Greek ones. Perhaps doing so was an exercise in hedging all bets: He wanted to be sure that he didn't offend any powerful deity that might come back to haunt him. It was commonplace to find a temple to an unknown god, just in case one had been inadvertently forgotten. There was nothing chauvinistic or nationalistic about Alexander's view of divinity. He sought the assistance of foreign gods, or at least he asked that they not interfere with his ambitions.

Alexander also took seriously oracles, temples run by priests who could foretell—cryptically—the future. On his return to Babylon after fighting for eight years in the East, the king would not enter the city because the oracles told him not to. How the priests arrived at their oracular forecasts was a well-kept secret, but it was usually by consulting the livers of dead chickens or watching the flights of birds. These soothsayers or prophets were very common in the ancient world; indeed, stories abound of famous encounters with the prophets. The death of Julius Caesar was foretold by both the interpretation of his wife's dream the night before his assassination and the words of the soothsayer who attempted to warn him on the day of his death. Philip was told on the night Alexander was born that his son was destined for greatness.

Another famous story concerns the untying of the Gordian

knot. Shortly after one of Alexander's first victories, the Battle of Granicus, he learned that a few miles away a certain King Gordias had left as a legacy a very difficult knot to untie. It was said (probably by Alexander's propagandists) that whoever untied the knot would conquer all of Asia. Sources disagree about what happened. Some say that Alexander cleverly untied the knot, others that he simply unsheathed his sword and cut it. But one way or another he untied or "cut the Gordian knot." Fox relates the tale this way:

On the day before leaving Gordium he went up to the acropolis meaning to try the chariot which he had saved for his farewell; friends gathered round to watch him, but hard though he pulled, the knot round the yoke remained stubbornly tight. When no end could be found, Alexander began to lose patience, for failure would not go down well with his men. Drawing his sword, he slashed the knot in half, producing the necessary end and correctly claiming that the knot was loosed, if not untied. The aged Aristobulus (one of Alexander's early historians) . . . later claimed that Alexander had pulled a pin out of the chariot-link and drawn the yoke out sideways through the knot, but the sword-cut has the weight of authority behind it and is preferable to an eighty-year-old historian's apology; either way, Alexander outmaneuvered, rather

than unravelled, his problem. He also managed to
arouse an interest in what he had done. "There
were thunderclaps and flashes of lightning that
very night," conveniently signifying that Zeus ap-
proved, so Alexander offered sacrifice to the "gods
who had sent the signs and ratified his loosing of
the knot." As a king under Zeus's protection, he
then encouraged gossip and flattery to elaborate on
his efforts.[15]

Alexander believed that untying (or cutting) the Gordian
knot would enable him to become "lord of Asia." This was ob-
viously an indulgence on his part in wish fulfillment, but he
would not stop until he reached the Indus River in northern
India.

Before he set out to the East, Alexander consulted the ora-
cle at Delphi in Greece, by far the most famous of the Greek
oracles. According to a common story, the oracle was closed
from mid-November until mid-February—the oracle would
not speak during those months. When Alexander called for
the priestess Pythia to come out, she said she could not—it
would be unlawful. Impatiently, Alexander proceeded to drag
the priestess to the place where she usually prophesied, when
she yelled out, "My son, you are invincible!" This was enough
to gratify Alexander, and soon thereafter he left for the East.

When Alexander reached the Egyptian capital of Memphis
on the Nile, he discovered that two hundred miles out in the
Libyan Desert there was another famous oracle at Siwah. He

immediately took a bodyguard and went there, being guided to the shrine, we are told, by crows. Once he had made sacrifice at Siwah—the priests did not taste meat often, the place being so isolated—he consulted the oracle there in a small room. Alexander never revealed what took place at Siwah's oracle, but he was satisfied and emboldened. He decided that the Egyptian supergod Ammon was the same as Zeus and thereafter usually prayed to Ammon Zeus. Plutarch tells us:

When Alexander reached the oasis, after the desert crossing, the prophet of Ammon addressed him with greetings from the god, who he implied was Alexander's father. Alexander then asked if any of his father's assassins had escaped him. The prophet told him not to blaspheme, for he had no mortal father, at which point Alexander reworded the question, asking if he had succeeded in punishing all Philip's assassins. He then asked about his own empire and inquired whether the god granted him mastery over all men. The god replied that he was granting him this and the revenge of Philip was now complete. Alexander presented the god with spectacular offerings, and his human assistants with money.

Such is the account of the oracles that most authors give, but Alexander himself in a letter to his mother says that a number of secret responses were given to him, which he would tell her on his return,

but in the strictest confidence. Some say the prophet, to be friendly, wanted to address him in Greek as *"O paidion"* ("Oh, my son") but because of his foreign accent he lapsed into a *sigma* at the end of the phrase, and said *"O paidios"* using the *sigma* instead of a *nu*. Alexander, they say, was pleased with this slip of the tongue and the story got around that the god had addressed him as the son of Zeus (*pai Dios*).[16]

After this encounter Alexander went further than worship of and sacrifice to Zeus. He decided that Zeus had copulated directly with his mother—a common occurrence between gods and humans—and entered her womb. Henceforth he sometimes referred to his father, Philip III, as my "so-called father." Ammon Zeus was his real father, he implied. It is likely that this fatherhood by Ammon Zeus was not just propaganda but something he sincerely believed.

Nonetheless, it is uncertain whether Alexander considered himself a god. He was encouraged to do so by his world conquest. In later times the Romans' recognition of Alexander as divine fit in with their own deification of emperors. From Claudius on, Roman emperors, notably Nero, Caligula, and Caracalla (all tyrants in their own right), considered themselves divine and emulated Alexander in dress and ceremony.

After Alexander had defeated Darius and assumed the throne of Persia as a direct heir, in recognition of the Persian ruler's divinity, he adopted both the Persian custom of wearing a diadem and the act of *proskynesis*, whereby everyone had to

approach the king groveling on hands and knees to kiss his feet. (See the story of Esther in the Old Testament of the Bible.) Most of the Macedonians in his army refused to make *proskynesis* to him as a god; therefore, in deference to their Greek sensibilities, Alexander did not mandate this ceremony for his army, but he expected his Persian subjects to observe it.

Alexander could be said to have assumed divinity in the East, but was cautious about doing so in the West. Demosthenes, the Greek orator who had no love for the royal Macedonians, said Alexander could be a god for all he cared, as long as he left Athens alone. After his death Alexander was widely recognized as divine. During his lifetime he was careful about proclaiming categorically that he was a god, but he probably thought that he was one.

Very few portraits of Alexander have survived the ages. We have a few coins with his image, the famous picture of Alexander on Bucephalus, and some physical descriptions of him. He was fair-skinned yet ruddy; he had an agreeable odor yet was hot and fiery; he was short yet not that short. One ridiculous story is told about his height when he met King Porus in India. Porus agreed to fight a duel with Alexander because he knew that he could win. The story gives Porus's height at five cubits, Alexander's at not even three. In translation, with a Latin cubit roughly eighteen inches, this would have meant that Porus was seven and a half feet tall and Alexander a mere four feet six inches tall. More than likely he was about the height of Napoleon, or about five feet six inches.

Aelian remarks, "They say that Alexander, son of Philip, enjoyed natural good looks, with curly, fair hair, but they add that there was something in his appearance that aroused fear."[17]

Alexander assumed his father's throne at the age of twenty and immediately began a life of conquest. His career took him to Persia and ultimately to India, where he was stopped. His death in Babylon in 323 BC occurred after several successive days and nights of drinking, but by this time his health was marginal. His death has been attributed to any number of sources—acute alcoholism, malaria, typhoid, and poisoning. He had been suffering from a fever for three or four days, yet he continued with his routine of giving orders to his men and making his usual sacrifices to the gods. Diodorus Siculus gives one account of his actual death:

> The seers instructed Alexander to make lavish sacrifices to the gods, and meanwhile he received an extremely importunate invitation to a drinking party in the quarters of one of his friends, the Thessalian Medius. There he consumed large quantities of neat wine, eventually filling, and draining, the great "cup of Heracles." All of a sudden he let out a loud cry of pain, as if he had been struck a severe blow, at which his friends took him by the hand and escorted him out. His personal attendants took charge of him, immediately putting him to bed

and keeping a careful watch over him, but his distress worsened and the doctors were summoned. None of them could help him, and he was continually wracked with multiple pains and excruciating suffering.

Losing all hope of surviving, Alexander removed his ring and gave it to Perdiccas. His friends asked: "To whom do you leave the throne?" and he answered "To the strongest," adding to this what were to be his final words that the foremost of his friends would all organize a great funerary contest in his honour.

So Alexander died, in the manner described above, after a rule of twelve years and seven months, and after accomplishing the greatest of feats, greater than those not only of the rulers that preceded him, but of those who were to come after him, right down to our day.[18]

The main story about poisoning comes from Quintus Curtius Rufus. He states that the king had been dead for six days, lying in a coffin. Everybody was involved in forming a new government. When his friends finally found time to attend the corpse, they saw that there had been no decomposition of the body. In the heat of Mesopotamia, this was completely unheard of. A golden sarcophagus was filled with perfumes and his body was taken to Memphis by Ptolemy, who had received

the power of Egypt. Some time later, the coffin was transferred to Alexandria.

The man who gained the most from Alexander's death was Antipater, who usurped the power in Macedon and Greece afterward. Alexander himself believed that Antipater had regal aspirations and was conceited enough to claim that any honors Alexander bestowed on him were nothing more than his due. One of Antipater's sons was an attendant to the king; another was Cassander, who ultimately murdered Olympias, Roxane, and Roxane's newborn child.[19]

The conqueror of the world was dead at the age of thirty-three.

THREE

The March of Conquest

PHILIP II of Macedon had left to his son Alexander the most powerful army that had been seen in Europe and western Asia before the rise of Roman military might in the second century BC. He also left Alexander a lot of enemies. It was by no means certain that the Macedonians in general or the army in particular would accept Alexander's rule. He was, after all, only twenty, and many others in the court believed that they had more experience and as much right to rule as he did. Macedonia did not have a strict right of primogeniture or succession, and Philip himself had not made himself clear regarding his preferred heir. Philip's death had set off a wave of

rebellion, not only in the Greek city-states but also in the far reaches of Macedonia itself.

In addition Darius was certain that Alexander was planning a march into Asia, as he was continuing his father's war plans. Darius further complicated the matter by sending envoys to the various cities with large bags of gold for the purpose of bribing any and all who could be bribed to cause trouble for Alexander and prevent him from holding together the tenuous Greek alliance.

Alexander did not immediately kill his small half-brother or Amyntas, who was married to Alexander's sister and a likely contender for the throne. With his father's body barely cold, these murders would have been too risky for his reputation.

The most apparent hostility came first from Athens. There Demosthenes, who had been spewing venom against Philip for years, now turned his anger against Alexander. He believed that the best way to topple Alexander was to make an alliance with those who backed the widow, Cleopatra, and her young son, Caranus. He proposed this to Attalus, the man who had set in motion the events that led to Philip's death; and to Parmenion, Philip's primary general, who had no love for Alexander. Demosthenes' comment to them showed the extent of his hatred but little knowledge of Alexander, whom he derided as "a stripling, a mere booby."[1]

While all these troubles were brewing, Alexander decided that a strong display of power was needed. Any backing down would be seen as weakness. He rode south from the Macedonian capital of Pella into Thessaly. He found the pass at

Mount Olympus strongly fortified, and he could not get through. While the Thessalonians were trying to decide what to do, Alexander ordered his men to cut steps in the side of the mountain; he crossed the mountains and was behind the opposing army before they knew what had happened. At this point they chose to negotiate rather than fight, gave Alexander a large contingent of cavalry, and agreed to pay taxes.[2]

All Alexander asked of the various sections of Greece was that they acknowledge him as *hegemon*, or leader. He made peace with Parmenion, his father's old general, and with his brother-in-law, Amyntas—both of whom did a complete about-face and came back to Alexander's side. He called a meeting of the Hellenic League at Corinth, with representatives from all the cities and provinces "invited" to attend. From all over the peninsula support poured in, except from Sparta. Alexander ignored the Spartans for the time being, since he was attempting to give the impression that he was acting according to constitutional procedure. He gave the Greek city-states the outward semblance of autonomy, which he believed would satisfy them. Alexander was elected captain-general of all their forces to lead the war against Persia. In addition each city-state was required to supply a certain number of soldiers and finance them as well.

After the conference was over, Alexander received the congratulations of all involved, but he decided to pay a visit to Diogenes, the famous cynic who traipsed around looking for an honest man and went home at night to a large clay tub, in which he lived. Green tells the story:

Piqued and curious, Alexander eventually went out to the suburb where Diogenes lived, in his large clay tub, and approached him personally. He found the philosopher sunning himself, naked except for a loincloth. Diogenes, his meditations disturbed by the noise and laughter of the numerous courtiers who came flocking at the captain-general's heels, looked up at Alexander with a direct, uncomfortable gaze, but said nothing.

For once in his life, Alexander was somewhat embarrassed. He greeted Diogenes with elaborate formality, and waited. Diogenes remained silent. At last, in desperation, Alexander asked if there was anything the philosopher wanted, anything he, Alexander, could do for him? "Yes," came the famous answer, "stand aside; you're keeping the sun off me." That was the end of the interview. . . . Alexander's followers tried to turn the episode into a joke, jeering at Diogenes and belittling his pretensions. But the captain-general silenced them with one enigmatic remark. "If I were not Alexander," he said, "I would be Diogenes."[3]

Diogenes wanted nothing to do with the world; Alexander wanted to conquer it. The two men died on the same day: Alexander at thirty-three, Diogenes at ninety.

That winter of 336–35 BC was spent in preparations for the Asian war, but Alexander knew that he had to have peace at

home before he could safely go abroad. He needed the financial support of Greece until he was able to secure the immense treasure of Darius. One characteristic that made Alexander an outstanding commander was his ability to "read" his enemy's mind. He demonstrated this in several battles, in Thrace, against the Triballians (nomadic people who opposed him on the shores of the Danube), and against the Illyrians.

In the case of the Triballians, he sent his archers and slingers out, apparently alone, and kept his phalanx and cavalry under cover. The Triballians came out, thinking they were opposed only by arrows and rocks. Alexander brought his superior force from hiding and cut down 3,000 natives in one charge. Very shortly the remaining Triballians came out of hiding and wanted peace and alliances with such a great warrior.

Against the Illyrians, Alexander miscalculated and found his army cut off from his supplies and relief column. According to Green:

> The young king extricated himself [in] one of the
> most eccentrically brilliant stratagems in the whole
> history of warfare. Early next morning he formed
> up his entire army in the plain—apparently oblivi-
> ous to the presence of the enemy—and proceeded
> to give an exhibition of close-order drill. The *pha-*
> *lanx* was paraded in files 120 men deep, with a
> squadron of 200 cavalry on either flank. By Alexan-
> der's express command, these drill-maneuvers were
> carried out in total silence. At given signals the

great forest of *sarissas* would rise to the vertical salute position, and then dip horizontally as for battle-order. The bristling spear-line swung now right, now left, in perfect unison. The phalanx advanced, wheeled into column and line, moved through various intricate formations as though on the parade-ground—all without a word being uttered.

The barbarians had never seen anything like it. From their positions in the surrounding hills they stared down at this weird ritual, scarcely able to believe their eyes. Then, little by little, one straggling group after another began to edge closer, half-terrified, half-enthralled. Alexander watched them, waiting for the psychological moment. Then, at last, he gave his final pre-arranged signal. The left wing of the cavalry . . . charged. . . . Every man of the *phalanx* beat his spear on his shield, and from thousands of throats there went up the terrible ululating Macedonian war-cry—*"Alalalalai!"*—echoing and reverberating from the mountains. This sudden, shattering explosion of sound, especially after the dead stillness which had preceded it, completely unnerved [the] tribesmen, who fled back in wild confusion . . . to the safety of their fortress. . . . The tribesmen . . . realized that the Macedonians were on the point of breaking out of the trap so carefully laid for them. They rallied, and counter-

attacked. . . . Alexander, with the cavalry and his light-armed troops, held them off . . . long enough for his siege-catapults to be carried through the ford and set up on the further bank. . . . "This is the first recorded use of catapults as field artillery." . . . Once again [Alexander] had concluded a complex and hazardous operation without losing a single man.[4]

Alexander ended this battle with a "Trojan horse" stratagem. He ordered his men to march away, leading the Illyrians to believe that they had left for good. He waited and sent back a reconnaissance party, which discovered that the barbarians had left their camp completely unguarded. He then marched back and, under cover of darkness, massacred the entire camp.

These various defeats and slaughters should have warned the rest of the Greek peninsula of Alexander's seriousness and that opposing him was futile. It didn't happen that way, however. The first rebellion broke out in Thebes. Darius had been channeling money into Greece, spreading it around where it would do the most good, and Alexander had yet to establish total domination.

Alexander heard that the rebellion was being backed by Demosthenes with arms and gold, and debated marching against Athens. Cooler heads in Athens did not want a direct clash with the Macedonian leader; and with Sparta refusing to join Alexander, the entire peninsula was ready to explode. Alexander realized that the time for diplomacy and kid gloves

had passed, and he was going to have to make an object lesson of someone: It fell to the Thebans to be that example.

The first thing Alexander did was send word to Pella, his capital, that he was returning. He sent a coded message for his mother, telling her to arrange the immediate deaths of his brother-in-law, Amyntas, and Cleopatra's baby son. Olympias went one better and killed not only Caranus but also Philip's daughter by Cleopatra. She then forced Cleopatra to hang herself. Amyntas fled to Asia Minor (and offered his services to Darius); he later was killed there.

Alexander then moved toward Thebes. For some foolish reason, Demosthenes had told the Thebans that Alexander had been killed. They felt fairly secure with this news, and when they heard that a Macedonian army was approaching commanded by Alexander himself, they panicked. He really did not want to waste his time and efforts on pacifying Greeks, so if they had met him halfway, he probably would have let the entire rebellion go. However, the Thebans were stubborn to a fault: They had passed a unanimous resolution that they would fight to gain full political freedom from Macedonia.

Alexander felt he was within his constitutional rights to coerce Thebes, since its rebellion was technically against the Hellenic League, whose captain-general he was. Alexander offered amnesty in exchange for their handing over the ringleaders of the revolt. Rather than accept his deal the Thebans defied the idea, and called Alexander a tyrant for good measure. Diodorus tells us that Alexander "decided to destroy the

city utterly and by this act of terror take the heart out of anyone else who might venture to rise against him."[5]

The siege engines were brought up, and the city walls were penetrated. The citizens lost heart and attempted to flee. Alexander's veterans poured into Thebes, and savage street fighting quickly degenerated into wholesale slaughter. The houses were ransacked, the temples destroyed and plundered. By nightfall 6,000 Thebans had been killed and about 30,000 taken prisoner, later to be sold as slaves to augment the Macedonian treasury for the impending war against Darius. The city of legend and history where Oedipus had ruled was blotted from the face of the earth.[6] Alexander might have been better served in the long run if he had spared Thebes and brought about a genuine alliance with the Greek city-states. They were shocked at first, but after the initial shock wore off, their hatred for Alexander became implacable. They pretended to be his friends because it was militarily necessary, but their obsequious behavior masked their true feelings. They continued to get gifts from Darius to fund their sabotage of Alexander—as he must have known would happen. The peninsula remained quiet for the moment, and Alexander must have felt that the time to advance into Persia was at hand.

At this point Alexander's advisers thought he should marry and beget an heir. He refused on the grounds that he had no time to dally with a matrimonial alliance. He had never been too interested in women anyway, so his lack of time did not

create any hardship for him, except that it calls into question his judgment. To leave a major decision about an heir in abeyance while he marched into the great unknown was evidence of his irresponsibility. He was more interested in conquest, apparently, than in a dynasty. Perhaps his age also had something to do with this decision. After all, what twenty-year-old believes that he will die young?

According to Green, Alexander was the first general in antiquity to have a publicity and propaganda department. To supply this official record, Alexander hired Aristotle's nephew Callisthenes to be the official historian. This turned out to be a mixed blessing—Callisthenes had known Alexander since they were boys, but he had a familiarity that irritated Alexander. His job was to make a chronicle of the king's exploits that would read well back in Greece.[7]

Alexander inherited an army that was well trained, but a country that was heavily in debt. Even with the vast resources and wealth of Macedonia, according to Plutarch, "Philip's financial resources were depleted, and he was also encumbered with a debt of 200 talents, according to Onesicritus' history."[8] He intended to finance his adventure with money and gold taken from the Persians.

The numbers of Alexander's army vary from author to author. Plutarch says that the army had 3,000 infantry and 4,000 cavalry, but the numbers could have been as high as 43,000 infantry and 5,000 cavalry. Diodorus Siculus tells us, "In terms of infantry, there were 12,000 Macedonians, 7,000 allies, and 5,000 mercenaries. These were all under the

command of Parmenion. The Odrysians, Triballians, and Illyrians accompanying him numbered 7,000 and there were a thousand archers and so-called Agrianes, so that the infantry totalled 32,000. Cavalry numbers were as follows: 1,800 Macedonians; . . . 1,800 Thessalians; . . . from the rest of Greece a total of 600; . . . and 900 Thracian guides. . . . This made a total of 4,500 cavalry [actually 5,100]."[9] Only about 10 percent of the entire army were heavily armed and armored cavalry. In contrast the Roman army at its height usually commanded 98 percent infantry, but the Romans had to guard a frontier that needed two million men to staff. They could not afford a large contingent of cavalry—that would require too many horses, and too much training.

Philip had recruited horsemen from Macedonia and neighboring Balkan countries and made them undergo several years of training. The long training was necessary because although the horses had saddles and bridles, the stirrup had not yet been imported from India (it did not reach Western Europe until AD 750). The Macedonian cavalry's horses were imported from countries such as Romania, Bulgaria, and Albania.

Despite this careful breeding, the Macedonian cavalry rode into battle on horses that were not more than two-thirds the size and weight of horses used in the late Middle Ages or today. In the absence of stirrups, the cavalry had to guide the horses with their thighs and knees while holding onto the horses' manes. The cavalry was equipped with throwing spears and small shields, but its favorite and most reliable weapon was the short sword. The cavalrymen wore iron breastplates and

helmets. The Persian cavalry was similarly armed and horsed, and there was little difference in quality between the Persian and the Macedonian cavalry. The difference lay in Alexander's tactical genius when he attacked the Persians.

Arrian provides a graphic account of Alexander on the battlefield:

> When the armies were now closing in on each other, Alexander rode the whole length of the line calling on his men to show courage. He addressed by name, and with appropriate honours and titles, not just the generals, but squadron leaders, company commanders and any of the foreign mercenaries that had some reputation for their superior rank or their courage. And the cry came back to him from every quarter—he should lose no time now in making his attack on the enemy. Even so, Alexander continued to lead them forward, in battle order, at a measured pace, despite now having Darius' force in view; he did not want to have any component of his phalanx become distended through too swift a march and so cause it to disintegrate. But when they were within javelin range, Alexander's entourage and Alexander himself (he was positioned on the right) charged to the river ahead of the others, intending to strike alarm into the Persians with a lightning attack and to minimize damage

from the archers by coming swiftly to hand-to-hand combat.[10]

The critical difference between the Persian army and the Macedonian army was not in cavalry but in infantry. The latter was divided into a heavily armed and armored contingent—the phalanx—and light infantry called *hypaspists* (shield-bearers). The phalanx soldiers were trained to work in units of sixteen, closely packed together. Their eighteen-foot-long *sarissas* (spears with pikes at the end) were the terror of Europe and western Asia. The cavalry would advance first and throw the opposing infantry into disarray. Alexander's soldiers tilted their *sarissas* forward then marched ahead in tightly packed ranks.

"Nobody who faced them ever forgot the sight; they kept time to their roaring of the Greeks' ancient war cry. . . . Their scarlet cloaks billowed, and the measured swishing of their sarissas, up and down, left and right, seemed to frightened observers like the quills of a metal porcupine."[11] These soldiers were well trained, disciplined, well fed, and very well paid. Not just the companions of Alexander's cavalry had these benefits. He enriched the infantry phalanx and *hypaspists* as well. The light infantry consisted of many Balkan peoples and mercenaries drawn from all over Greece.

Alexander crossed the Hellespont (Dardanelles) that separated Europe and Asia in 334 BC. It took 150 triremes (boats with

three banks of oars) to transport the whole army. Not one Persian vessel was spotted—fortunately, because the expedition could have been ended before it got under way if Darius had been astute enough to contest the crossing. But the Persian command was not famous for military strategy, relying more on sheer numbers. It must be stressed again that had the king of kings, Darius III, maximized his military resources at any time, he could have put 150,000 cavalry and infantry into the field against Alexander and possibly have swamped Alexander's army of 40,000. As it was, the Persian forces (initially including many Greek mercenaries) rarely numbered more than 75,000 in any engagement. The fact that the Persian emperor acted so minimally was probably due to his belief in the invincibility of his army and navy, which caused him to take the Macedonian threat too lightly in the beginning.

Alexander sensed that his opponent was a weakling, too lethargic and confused even to summon his potentially much larger army for a particular battle. Darius had been surrounded by eunuchs and concubines too long. He was a soft man.

According to Green:

> Ever since childhood he had dreamed of this moment: now the dream had been fulfilled, and he was entering on his destiny of conquest. Few men can ever have given such solid embodiment to their private myths. He was the young Achilles, sailing once more for the windy plains of Troy; but he was also captain-general of the Hellenes, whose task it

was to exact just vengeance for Xerxes' invasion of Greece. The two roles merged in his mind, as the two events had merged in history. Xerxes had made it clear that his expedition was the Trojan War in reverse; Alexander therefore in turn reversed the details of this most famous of all oriental attack [sic].[12]

As Heinrich Schleimann would do centuries later, Alexander carried his well-worn copy of Homer's *Iliad* with him, because he crossed the Hellespont at exactly the same place the early Greeks had. As Alexander marched through Turkey, he freed Greek cities in his path, but the Persian army kept in advance of him without offering any serious resistance.

Memnon of Rhodes, Darius's commander in Asia Minor, was a very good general. He had offered his services to Darius many years before, and even though he was a Greek and had traveled to Philip's Macedonia, he had no liking for Philip's son, Alexander. Getting little in the way of instructions from Darius, Memnon advised a "scorched-earth" policy because it was common knowledge that Alexander was in financial straits and would need the land and its produce to survive. Memnon felt this was the best solution to the Macedonian invasion. He requested permission to destroy the crops and other foodstuffs in the path of Alexander's army, leaving Alexander's army to starve and then—it was hoped—retreat.

Foolishly the Persian lords would not let Memnon carry out his policy. Perhaps they were envious of the Greek general's

rise to power in their land, but more plausibly they had great estates with hordes of slaves and wanted to continue their easy living. Without scorched earth tactics and with the Persian lords seemingly willing to accommodate themselves to Alexander's rule, there was little Memnon could do. He watched helplessly as the cities of Asia Minor, many of them Greek colonies on the coastline, surrendered peacefully with very little fight.

Alexander allowed the Persian satraps and lords to remain in place for the time being. They had not opposed him as yet, and in fact had denied Memnon the tactic whereby the war would have ended before it began.

Finally the Persian emperor could hesitate no longer. He put an army of 75,000 into the field under Memnon's command on the banks of the Granicus River (now called the Kocabas River), which flows into the Sea of Marmara. It is noticeable that Alexander's battles usually took place on the bank of a river. This site suited Alexander and his commanders but was less advantageous to the Persians. They had difficulty deploying their larger numbers in the narrow topography of a riverbank.

The one weapon that was unique to the Persians, the scythed chariot, was also hard to deploy in a cramped, muddy riverbank. Had the Persian emperor used his potential army of 150,000 soldiers and deployed them on a wide plain away from the river, the outcome of the battle would undoubtedly have been very different.

The Granicus River was about sixty feet wide, with a fast current. Alexander's troops were going to have to charge down a steep embankment, go through the swift water, and then scramble up the slippery slope on the other side. This would obviously make them extremely vulnerable when they attempted to reassemble on the far side. Alexander, with characteristic bravado, wanted to cross immediately, even though it was late, they had marched all day, and the men were tired. His generals, led by Parmenion, advised that they wait until morning and cross farther downriver, where the current was not so fast. That way, they argued, his men would be fresh and rested and could be on the other side of the river before the Persians knew what had happened.

Alexander argued, but he eventually realized they were right. The battle took place the next day. Alexander drove his cavalry directly into the midst of the Persian army, first to the right, then the left. He lost his spear in the first charge, but he stayed right in the thick of the fighting.

Plutarch gives us a vivid, albeit somewhat inaccurate, account of the early phase of the Battle of Granicus:

> Alexander plunged into the river with thirteen cavalry squadrons. He was now driving into enemy projectiles and heading towards an area that was sheer and protected by armed men and cavalry, and negotiating a current that swept his men off their feet and pulled them under. His leadership seemed

madcap and senseless rather than prudent. Even so, he persisted with the crossing and, after great effort and hardship, made it to the targeted area, which was wet and slippery with mud. He was immediately forced into a disorganized battle and to engage, man against man, the enemies who came bearing down on them before the troops making the crossing could get into some sort of formation.[13]

Alexander lost his lance and his horse (not Bucephalus, who either was lame at the time or was considered too valuable to use in this battle), and he suffered a head wound where a saber blow from a Persian nobleman penetrated Alexander's helmet and cut completely through to the skull. Alexander fell off his horse, and the battle continued over him. Somehow he managed to get back astride, and with his rallying companions, he broke the Persian flanks and they retreated. Memnon got away, but an estimated 2,500 Persian cavalrymen were killed.

Alexander won the Battle of Granicus by using his cavalry as a disruptive force aimed directly at the Persian army. He drove his cavalry right into the middle of the Persian infantry. This shock deployment of cavalry seems to have been first used by Alexander. Previously cavalry had been used only in flanking maneuvers.

After the Battle of Granicus, Alexander buried the dead, both Macedonians and Persians, on the battlefield. The Persians generally cremated their dead, rather than bury them, so what seemed to Alexander to be a magnanimous gesture was

actually a slap in the face to their religious observances. He was always inclined to give recognition and honor to the dead among his opponents. First he killed them; then he buried them with military honors. (The British were still following this tradition in World War I.)

Many of the Persian soldiers were Greek mercenaries. These Alexander had rounded up and sent back to Macedonia to work as slaves in the mines. In this way Alexander gave a severe object lesson to any other Greek who might contemplate fighting for Darius. Technically the Greek mercenaries were traitors to the Greek alliance, of which Alexander was the head. Some of the spoils of war were sent home to Olympias, who was acting as regent in Alexander's absence. In addition he sent three hundred panoplies back to Athens to be dedicated in the Parthenon with the inscription, "Alexander son of Philip and the Greeks—Lacedaemonians (Spartans) excepted—these spoils from the barbarians who dwell in Asia."[14]

At this battle Darius had to recognize the serious threat that Alexander posed to his entire empire. Asia Minor was now open to him. Perhaps even Alexander, with his visions of conquest, was unable to recognize how long and dangerous the rest of the journey would be. For Aristotle, the Athenian philosopher and Alexander's tutor, the known world ended in India. (China was still outside the Greek recognizance.) And India was where Alexander wanted to end up, *after* he conquered the Persian Empire.

It is uncertain if Alexander had any clear-cut plan for the Persian Empire in mind. Did he intend to merely defeat Darius

or completely replace him? It seemed that he was going to keep going and wherever he ended up was where he would be. He was an adventurer as much as a conqueror.

Alexander had left Greece and its problems in the hands of Antipater (along with his mother), with the orders that he was to squelch any incipient signs of rebellion by whatever means were necessary. He could install dictators and oligarchs freely to control the population and quell any dissent that arose.

Along his road between the Battle of Granicus and the upcoming major Battle of Issus, Alexander knew that he had to control the population in Asia Minor, since it would be at his back as he moved farther into the Persian Empire. Most of these provinces and cities were ruled by heavy-handed tyrants, and since part of Alexander's modus operandi was to appear to be a liberator, he did the reverse of what he had ordered for Greece: Where he found a tyrant, he freed the people. He had no problem in his own mind of playing the role of tyrant in one place and liberator in another. He had no scruples about using whatever means served his purposes.

As Alexander marched his army inexorably toward the capital city of Susa, he was gratified to see that his victory at Granicus had convinced many of the Persian satraps that they would be better off surrendering peacefully. The governor of Sardis was the first of them to capitulate, along with his garrison. At each juncture Alexander replaced the Persian governor with one of his own choosing, spreading his Macedonian officers around with the apparent intention of not permitting unlimited power to be held by any one of them. He appointed

a department to collect taxes and tribute from the satrapies to separate the monetary function from the governing functions. This improved civil administration, but it also kept control of the finances out of the control of the governors.

Otherwise he permitted all the other mechanisms of government to run as they always had. He allowed the customs of the country to remain in place and made no attempt to impose Greek ways on anyone. Alexandrian freedom meant no more than a guarantee against enslavement.[15]

In Ephesus he commissioned a portrait of himself from a local painter, his plan being to be astride Bucephalus in the picture. When Alexander saw the finished product, he did not like it. The artist then had him bring the horse to the studio, and another picture was produced, this time with Alexander astride the horse with a thunderbolt in his hand, reminiscent of Zeus. This one he liked. It was one of the first times in history that art was used as propaganda. It suited Alexander at this point to hint at his godlike stature, and self-deification was obviously an idea that he was toying with.

Ambassadors from Greek communities in Asia Minor continued to come to him, offering submission and allegiance in exchange for his permitting their "democracies" to continue. Alexander was very generous with these cities, remitting their Persian taxes but insisting they join the Hellenic League, so that it then became their duty to give cash contributions to the war effort. Though a tax by any other name is still a tax, Alexander did not seem to have any problem dealing with this concept.

* * *

While Alexander was consolidating his support with the towns in Asia Minor, the Persian fleet was anchored off the coast trying to provoke an engagement. The naval abilities of the Persians were far superior to those of Alexander, and he had no desire to engage in any naval battle at this point in his journey. Eventually the fleet sailed away to establish a new defense at Halicarnassus.

Memnon had petitioned Darius for command of the army of lower Asia and command of the fleet, sending his wife and children to Susa as a guarantee of his loyalty. Since he was the only competent general the Persian army had, Darius gave the command to Memnon as Alexander marched south toward Halicarnassus.

The rightful queen of this city, Ada, had been driven from her throne by a usurping relative who had since died, and the city was being governed by an administrator appointed by Darius. Instead of marching straight to Halicarnassus, Alexander sidetracked to the town of Alinda, where Ada was living in exile. The inhabitants of Alinda were thrilled at the opportunity to have their rightful queen restored. Here Alexander was able to achieve true liberation. Ada voluntarily surrendered her forces to Alexander, and in return he gave her back her throne. She and Alexander developed an emotional bond, and she showered Alexander with gifts. He called her "mother," finding her much more amenable than his actual (maniacal) mother, Olympias.

"Ada pampered Alexander, sending him many cooked

delicacies and cakes every day and finally sending men thought to be the most talented cooks and pastry-makers available."[16] She must have learned that Alexander had a sweet tooth. When Ada died, she made Alexander her heir to inherit her city.

Alexander had said that his father, Philip of Macedon, was only his "so-called" father. As stated previously he preferred to regard the supreme deity Ammon Zeus as his true father. Now he had divested his mother, Olympias, of her biological status in preference of the more amiable and loving Ada of Halicarnassus. Thus Alexander had liberated himself from both his biological parents.

All through Asia Minor, Alexander followed the same pattern: He found cities under Persian rule, many of which were disaffected, and restored their "freedom." He replaced the Persian satraps with Macedonians, collected a "contribution" instead of a tax, and left their customs and institutions alone; and they gave him homage instead of giving it to Darius. This had been a rather peaceful conquest so far. But the fun was about to end; Alexander had restored Ada to her throne, but now he had to take the town of Halicarnassus.

Memnon had fortified the city with substantial troops, and his fleet controlled access by water. Alexander met with dissidents inside the city who made promises to open the gates one night and allow Alexander's troops to enter. However, the night Alexander appeared, the gates were barred and a fierce though small-scale battle ensued. He finally managed to break down one section of wall, and his men were able to enter the city through the rubble. Memnon had had catapults installed

on the city walls, however, and the Macedonian forces were showered with rocks, forcing them to retreat.

Memnon threw in his infantry reserves, and for all practical purposes Alexander had lost the battle. Miraculously, however, the seasoned veterans of Philip's wars saved the day. They advanced into the city in closed phalanx formation and took the Persian forces completely off guard. The local Persian commander was killed, and Memnon thought it best to leave the city to Alexander. Before he left, though, he set a massive fire, and because of the prevailing winds, much of the city was destroyed. Under cover of the fire, Memnon withdrew his forces, supplies, and equipment, so that when Alexander entered the city the next day, there was very little left.

At this point Memnon and Darius decided to take the war back to Greece. Their idea was to get Alexander's army in a pincer movement, with their forces behind him and in front of him. After the destruction of Thebes, Alexander had hardly endeared himself to the Greek city-states. Sparta had always refused to join him, and unrest in Athens was a continuing problem. Greece was on the brink of revolt. Memnon was spreading Darius's gold liberally through the peninsula, and it appeared as if Alexander would lose what tenuous support he had back home.

He was in a dilemma: If he continued to advance through Asia Minor, he would undoubtedly lose Greece, perhaps even Macedonia. He was near bankruptcy. It was at this time that he came to Gordium, untied the knot, and got a fresh slant on his problems. Maybe Greece seemed an insignificant part of

his plan now that the possibility of dominion over Asia was within his grasp.

Alexander received word that Darius was amassing a new army in Susa, so he started to march toward the capital. He initiated a new practice, which was to appoint local barons to govern, rather than leaving a Macedonian administration behind him. This began to cause some problems as small revolts erupted after he had moved his army out of the region, and at least three major battles were needed to keep his lines of communication open.

Welcome news came while Alexander was in Ancyra (now Ankara, Turkey) that Memnon, his fierce Greek challenger, was dead. Since Memnon had been the only good commander Darius had in Asia Minor, Alexander had renewed enthusiasm for his conquest of Persia.

Some of Darius's advisers thought the king of kings should personally lead the army, for psychological advantage if nothing else. Memnon's replacement, an Athenian named Charidemus, opposed the plan, saying it would be the height of folly for Darius to stake his throne on such a gamble. He felt that Darius should stay in Susa out of harm's way. Charidemus implied, in a meeting, that he was the best choice for command, since, as a Greek, he was a better general than any of the Persians.

Naturally the Persians took offense, a shouting match developed, and Charidemus made some very uncomplimentary remarks about Persians in general. Darius, who could speak Greek, ordered Charidemus seized and summarily executed. Almost immediately he regretted his actions, because he had

just ordered the death of the only competent general he had left, but it was too late. Another Persian took command, and Darius started his march from Babylon.

Meanwhile, in the heat of summer, Alexander was moving his army by forced march through Cappadocia, where for a stretch of seventy-five miles there was no water or other provisions. In front of them were the Taurus Mountains, with only one way to pass—through a gorge called the Gates. It was an extremely narrow defile that could be easily defended by a small force on the cliff, hurling down rocks. The local governor, named Arsames, had a glorified opinion of himself. He had been at Granicus, and he believed that the scorched-earth strategy Memnon had wanted to use there would work here. But Arsames was in a totally different terrain. If he had brought up his troops to defend the Gates, Alexander would have been forced back. Instead the foolish man left only a small force to hold the pass, and he and the rest of his army moved back and destroyed the entire Cilician Plain as they passed through. Believing they had been abandoned by their general, the contingent left to guard the Gates fled, and Alexander was able to pass through with no problems. He said afterward that he never had a more amazing piece of luck in his entire career.[17]

Arsames evacuated Tarsus, and Alexander entered the city in September 333. He was exhausted and hot. A river flowed through the center of the city, ice-cold from mountain snows. Alexander jumped into the water, immediately suffered a cramp, and had a convulsion. He was pulled from the water half

dead. The king had been fighting a slight bronchial infection, and he quickly developed pneumonia along with a high fever.

Most of his physicians refused to treat him because they feared that if he died, they would be held personally responsible. The Great King was offering a reward of 1,000 talents to anyone who killed Alexander, so perhaps the doctors had a legitimate fear.

Finally, one man, Philip of Acarnania, who had been Alexander's physician since he had been a child, agreed to treat him with a drug that carried some risk because it was a purgative, and he was obviously already weak. Alexander knew enough about pharmacology to permit the risk. He got much worse before he got better. His voice failed, he had great difficulty in breathing and he fell into a coma. Alexander's constitution was strong, however, and eventually he recovered. His troops had waited anxiously to hear news of his recovery or death, and it was with much relief that he had himself carried out on the third day for them to see that he was still alive.[18]

Darius III finally made his stand at the Battle of Issus in eastern Turkey. This province in Cilicia was one of the richest agricultural regions of the known world. Many a Roman governor later did very well ruling Cilicia. So there at the eastern extremity of Asia Minor, the king of kings took the field himself and rallied a large army. Its size remains undetermined: Some figures are as high as 500,000, others are as low as 75,000. Either way, it was substantially larger than Alexander's.

But once again the Persians had chosen a cramped riverbank

where they could not advantageously deploy their larger army. This is the battle that a Greek artist famously commemorated, showing Darius and Alexander personally confronting each other—Alexander on his horse Bucephalus, Darius in a scythed chariot.

Fierce fighting ensued. Darius was conspicuous in his high chariot, and Alexander obviously wanted the triumph of killing the king of kings. The carnage was immense. Most of Darius's best generals had been killed, while the number of Macedonian dead was very small. Darius's horses were injured and began to toss at the yoke, making Darius's perch very precarious. To save himself, he jumped down and mounted a horse, threw off his royal insignia, and fled the scene. His men consequently broke ranks and either surrendered or fled behind their hapless king.[19]

The Persian army was devastated, with perhaps 70,000 dead and 40,000 taken prisoner. Alexander's army lost a mere 280 men. Among the prisoners were the mother of Darius, his wife, and two of his daughters, along with large quantities of treasure.[20]

Alexander treated the women of Darius's family with great honor and kindness. His motives may not have been completely altruistic, however, because he undoubtedly knew from his studies with Aristotle of Persian customs and religion that inheritance in Persian royalty descended through the maternal side. An obvious solution to legitimizing his claim to Darius's throne would be a marriage between him and one of Darius's daughters. It is logical that Alexander would have considered

this. He was still unmarried and would eventually have to marry anyway. Why not consolidate his claim to the Achaemenid throne that way?

For the first time the Macedonians got a glimpse of the vast wealth of Darius they had been promised. His wagons and tents were full of plunder they could only have dreamed about, and their greed made persuading them to continue the advance much easier. They also added a large number of Persian concubines and prostitutes to their entourage.

Darius, fearing for the first time for his actual throne, sent a proposal to Alexander whereby he offered to pay a substantial ransom for the return of his womenfolk, agreed to sign a treaty of friendship and alliance, and agreed cede Alexander half of his empire. He was soon to be disappointed.

Alexander sent a reply that began, "King Alexander to Darius." The letter went on to say that Darius had been responsible for Philip's death, that he was a vulgar usurper who was attempting to take Macedonia away. He agreed to return the royal family without ransom, but he wanted Darius to know that they were not equals and that Alexander was to be addressed as king of all Asia. In addition, he challenged Darius to stand and fight if he wanted to dispute claims to the throne, but if he ran, he would be found wherever he might hide.[21] In this way Alexander revealed his entire plan—he wanted complete and sole power. He had no intention of sharing anything with Darius.

Alexander spent the next few months consolidating his

position along the coast and throughout Asia Minor. He knew that this would give Darius time to regroup his army also, but Alexander wanted to entice Darius into another battle, this one with his entire army, which Alexander intended to annihilate.

Alexander realized that before he could completely dominate Asia Minor, he had to thwart any efforts Darius might make from the sea. Darius kept most of his navy anchored in the ancient ports of Sidon and Tyre, in what is now Lebanon. The two cities had been enemies for centuries. There was no difficulty with Sidon; apparently the inhabitants were tired of Darius's rule and were perfectly content to yield to Alexander.

Tyre was another matter entirely. Though he was greeted hospitably enough, Alexander sensed much ambivalence in the ambassadors who came to talk to him. It became clear quickly that they would talk and bow but had no intention of submitting to his rule. When he offered to come into the city and make offerings to their god, Melkart (Melqart), during a local festival, they refused politely, telling him that they were maintaining their neutrality, that permitting him this royal prerogative would be tantamount to accepting his rule, and that until the war was over, neither Macedonian nor Persian could enter their city.

The fortress of Tyre was actually two cities—one on the mainland and one on an adjacent island. Alexander lacked the naval strength to attack the mainland directly, so he and his engineers conceived a grand plan. They would build a causeway, or mole, to carry his army across the half-mile strip of water.

This was a mammoth project, but Alexander never shirked from mammoth projects. His officers and men, on the other hand, were totally opposed to the project as madness.

They viewed the deep channel with trepidation and felt that their commander was asking too much. Alexander sent a final envoy into the city, asking for an alliance. The Tyrians took this as a sign of weakness, killed the envoys, and tossed their bodies over the walls. This convinced any doubters in Alexander's army, and the project began.

Before the siege was over, according to Josephus (a Jewish writer of the early first century), Alexander wrote to the high priest in Jerusalem, "requesting him to send him assistance and supply his army with provisions." Meanwhile, not only Alexander's own troops, but all able-bodied men from the surrounding towns and villages found themselves drafted into a vast emergency labor force, estimated at "many tens of thousands."[22] As the causeway came within striking distance of the mainland fortress, the Tyrians barraged Alexander's Macedonians with catapulted missiles of every description.

Once the causeway was completed, Alexander moved his siege catapults and battering rams to the city walls. Many of the cities in the area, deciding that they would throw in their lot with Alexander, sent ships, so that eventually he had a fleet of about one hundred. Now he planned a full-fledged attack, from land (by way of his mole) and sea. While his phalanxes pressed on land, his fleet battered from the sea. Alexander moved up his huge 150-foot siege towers, and boarding gangways were made ready. A breach was found in the walls, and Alexander's army

poured into the city. The Tyrians fought back fiercely, utilizing a new weapon: They filled huge metal bowls with sand and gravel; heated them to white-hot, producing what might be described as an ancient form of napalm; and then proceeded to dump these bowls on any hapless soldiers who came within range. The sand sifted inside the victim's armor and shirt, burning the flesh terribly. Alexander's men were forced to retreat.

The six-month siege was not working. Though Alexander debated abandoning it, giving up was not in accord with his personality. He set his battering rams against the fortress in earnest, until finally he found a weak spot. He sent his elite troops into the breach, and after hours of fighting, the city fell at last. Alexander's soldiers tore into the city and became butchers, killing and looting with abandon. Alexander had given the order that only those inhabitants seeking sanctuary in the temples were to be spared.

Seven thousand Tyrians died in this orgy of destruction, but the citizens of Sidon, though their city was a traditional enemy of Tyre, managed to smuggle some 15,000 Tyrians to safety. The remaining survivors, about 30,000, were sold into slavery. Two thousand men of military age were crucified. It was the Jewish prophet Zachariah who many years before had composed this epitaph: "Burden of the Lord's doom, where falls it now? . . . This is Tyre, how strong a fortress she has built, what gold and silver she has amassed, till they were as common as clay, as mire in the streets! Ay, but the Lord means to

dispossess her; cast into the sea, all that wealth of hers, and herself burnt to the ground!"[23]

In this way Alexander disposed of an entire city, punishing its people severely for their resistance and warning any others who stood in his way that his wrath was great for those who opposed him and his rule.

After the destruction of Tyre, most cities along the coast between there and Egypt hastened to capitulate to Alexander. The exception was Gaza, on the route into Egypt, which was defended by stout walls and was considered to be impregnable. Hephaestion was in command of the fleet off the coast, and Alexander approached the city by land with the bulk of the army. The catapults were put to work, but when the siege towers were brought toward the walls, they sank in the sand. Alexander was wounded in the shoulder by an arrow that completely pierced his corselet. He was carried off the field, only half conscious.

To take the city Alexander was forced to build a huge mound of earth all around it that would give his siege towers the height necessary to breach the walls. During the fighting, Alexander had his leg broken by an artillery stone. Perhaps the problem inherent in taking Gaza, plus his two wounds, put him in a worse temper than usual, because he ordered that the defenders of the city were to be killed and all women and children sold into slavery. The defender of the city, a huge eunuch named Batis, he had lashed by the ankles behind a chariot and

dragged to death around the walls of Gaza, an idea he must have gotten from *The Iliad*.[24]

From Gaza, Alexander marched into Egypt. The Egyptians had suffered particularly under Persian rule, since the Persians considered the country one big breadbasket for their consumption. They welcomed him with open arms and placed him on the throne of the pharaohs, giving him the double crown of Upper and Lower Egypt, and he simultaneously became the pharaoh, the incarnation of Ra and Osiris. Finally he had achieved godhood.

Unfortunately, at this point Alexander began to lose touch with his Macedonian core. The Macedonians were willing to put up with a lot, but they were far from sure about this deification. For his part Alexander seemed to scorn their opinion, pressing forward, this time to Siwah, where he was given his propitious prophecy. Since Siwah was some three hundred miles across desert, Alexander clearly had an intense desire to hear what the prophet had to say. As has been noted previously, he was not disappointed. He cleared up the matter of his divine origins and was given the go-ahead to build his city of Alexandria. From this point on Alexander always worshipped Ammon Zeus, so whatever epiphany he had made a lasting impression on him.

Before he got back out of the desert, Alexander had completely blocked out in his mind the plans for his new city. He set to work immediately, marking off the walls and the locations of certain buildings, including a temple to Isis, to ensure that this city would be a testament to his greatness. This he

accomplished, as the city of Alexandria was a spectacular sight for many years to come.

Alexander was deeply impressed with Egypt. He left the running of the country mainly in Egyptian hands; this was a good psychological move. The tax flow came into his pockets, but the administrators were Egyptians, a fact that deflected criticism from him personally.

Once the brief hiatus in Egypt was over, Alexander had to get back to the business at hand, which was to defeat Darius once and for all. After Darius had fled from the field at Issus, he took refuge in a town called Arbela (now Irbil, Iraq). The second and final battle between Darius and Alexander, in which Darius personally led his army, was the Battle of Gaugamela in northern Assyria near the Tigris River, considered to be one of the most decisive battles in history. In the autumn of 331 BC, this battle devastated the entire Persian Empire, and all the wealth of Babylon, Susa, and Persepolis was opened up to Alexander.

The army that Darius brought into the field at Gaugamela was much larger than any he had deployed so far. When Alexander saw the size of the encampment, he was alarmed, knowing that only superior tactics would enable him to succeed against such an overwhelming number of soldiers. To this end he stayed up all night before the battle and invented a tactical plan that would be imitated centuries later by Napoleon. His plan would draw the Persian cavalry units from the middle to be engaged by his own flank guards; then he would attack the weakened middle.[25]

The flat plain of Gaugamela was much more advantageous to the Persian forces and their scythed chariots than either the riverbanks of Granicus or the hilly area of Issus had been. There were times in the course of the struggle when it appeared that Darius would win. Early in the day a fierce thunderstorm with lightning had filled Alexander's army with fear. The lightning gave the appearance of fire, and the troops panicked. Alexander quickly ordered them to stop and rest until they had recovered their confidence.

By the end of the day, the main bodies of both armies were close together and the two kings were urging their men on to more effort. Darius was in his chariot and Alexander was on horseback. Both of them had a small number of guards who had no regard for their own lives, but were intent only on protecting their own king. While doing this, both groups hoped for the glory of killing the opposing king.

Darius's charioteer was run through by a spear, and both sides believed it was the king who had been killed. His army started a mournful wailing along with wild shouts and groans, and foolishly abandoned the king's chariot. Darius tried to avoid a cowardly flight by courting an honorable death, and he was ashamed to leave his troops. The Persian army gradually broke ranks and the battle turned into a massacre. Darius once again turned his chariot and fled the field.[26]

Alexander was greeted with open arms in Babylon, and Darius was still in flight. Babylon was the first step in making Alexander the richest man in the world, because the huge Persian treasury was now open to be plundered. For his part,

Alexander rewarded the Babylonians with a restoration of their temples and obeisance to their gods, which endeared him to the populace.

Alexander relaxed in Babylon for five weeks, taking in the sights. The walls were twelve miles in circumference, and the sacred ziggurat rose 270 feet into the air. Alexander took up residence in one of the two imposing palaces, which had six hundred rooms with four main reception areas. Around the palace buildings were the famous hanging gardens. Alexander's men took their comfort in the company of beautiful prostitutes whose ranks had been swelled by highborn women anxious to get in on the entertainment. Alexander paid his men for the first time in many months, from the Persian treasury. It was easy to forget that the war was still not over: Darius was still at large.

From Babylon, Alexander moved on to the next royal city, Susa. This city also lacked nothing in magnificence.

Susa had been built by the most talented craftsmen and goldsmiths who could be found in the Persian empire. The walls were covered with carvings, gold work, precious woods, and enamels. Purple embroidery, some of it 190 years old, but still fresh as new, adorned the walls and the bedchamber of the king. Next to his bed was his own personal treasury, with wealth unimagined even by Alexander—who ordered 3,000 talents, six times the annual income of Athens, to be sent back to Greece to help deal with the Spartan revolt.[27]

Learning that Darius had taken refuge in Hamadan (in present-day Iran), Alexander set out in pursuit. He received

word that Darius had been deposed and taken prisoner. The resistance was led by a Persian named Bessus, who went so far as to have himself declared king of kings. Darius was chained in an old covered wagon and moved along with Bessus's men. Obviously Bessus intended to use Darius as a bargaining tool if Alexander overcame them. To head off Bessus's troops, Alexander led a mad dash across fifty miles of desert in the middle of the night. He did get ahead of them, and they scattered in two directions. Since Alexander had no idea which group had Darius, his troops were set the task of scouring the area looking for him.

The end of Darius was pathetic. Green describes it:

> Meanwhile the oxen pulling Darius' now driverless waggon had wandered about half a mile off the road, down into a valley where there was water. Here they came to a standstill, bleeding from numerous wounds, and weakened by the heat. A thirsty Macedonian soldier called Polystratus, directed by peasants to the spring in the valley, saw this waggon standing there, and thought it odd that the oxen should have been stabbed rather than rounded up as booth. Then he heard the groans of a dying man. Naturally curious, he went over and drew back the hide curtains.
>
> There on the floor lay King Darius, still in chains, his royal mantle sodden with blood, the murderers' javelins protruding from his breast,

alone except for one faithful dog crouching beside him. He asked, weakly, for water. Polystratus fetched some in his helmet. Clasping the Macedonian's hand, Darius gave thanks to heaven that he had not died utterly alone and abandoned. Soon after this his laboured breathing dwindled into silence, and all was over. Polystratus at once took his news to the king. When Alexander stood, at last, before the broken corpse of his adversary, and saw the sordid, agonizing circumstances in which he had died, his distress was obvious and genuine. Taking off his own royal cloak, he placed it over the body. At his express command, Darius was borne back in state to Persepolis, and given a kingly burial, beside his Achaemenid forebears.[28]

Bessus had set up a rival government, and Alexander now had to act as if he were Darius's chosen successor. He gave the impression that Darius had named him his successor before dying and had asked Alexander to avenge his death. This was the height of irony, as Alexander had hounded Darius to his death, but assuming the role of Darius's avenger did not seem to bother him. He took the battle to Bessus, but the usurper managed to escape, and Alexander gave up pursuit for the time being.

Meanwhile his troops heard a rumor that the campaign was finished, that the conquest was over, and that they were going home. Alexander woke up one morning to find his men

packing. Since in his personal view the conquest was far from finished, this caused him some concern. He knew he had to address the troops to persuade them to stay, but the situation confronted him with a dilemma: If he came down on them too hard, they might rebel. In the end Alexander decided that the best tactic was to scare them into obedience.

He gave an impassioned speech in which he preyed on their fears. Their conquests were not yet secure. The Persians did not like them and refused to accept their sovereignty. Only the power and might of Macedonia could stave off rebellion and treachery, particularly that of Bessus, who had to be crushed in order for victory to be ensured. Alexander's troops responded as expected, and another crisis was averted.[29]

The throne to which Alexander had aspired and which now was his was an ancient one associated with ceremony and pomp. Access to the king had always been very limited, and visitors had to go through a thorough scrutiny before they could come into the king's presence. Even then they had to keep their hands hidden. They had to bathe and dress entirely in white. After they approached a certain distance from the throne, if the king did not beckon them on, it was a crime punishable by death to come closer.

The king's clothing was sewn with gold thread, and he wore only purple and white with gold embroidery. The horses pulling his chariot were white, and he was shaded constantly by a parasol held over his head by a servant. Another servant carried a fly-whisk. With jewelry of gold, padded yellow shoes, and a girdle woven of pure golden thread, the Persian king

was a god among men. His position was one that inspired awe and devotion, though little friendship.[30]

Alexander remained aware that living in such grandeur was not in keeping with his Macedonian roots; indeed, his men held such behavior in great disdain. It was only after Alexander was introduced to a young and extremely handsome court eunuch named Bagoas that he began to change his mind about Persian ways. It is unclear what Hephaestion thought of this new favorite, but Alexander's staff was discreet about his alliances, and Alexander obviously found the eunuch's companionship pleasant. In time Bagoas became a man of great influence over his patron.

It was at Bagoas's instigation that Alexander began to wear the purple-and-white-striped tunic, the girdle, and the head ribbon or diadem of the traditional Persian ruler. Access to him was strictly limited. These behaviors alone set him apart from the other Greeks, and emphasized his connection to Zeus, since a diadem was worn only by those who were favored by Zeus. In addition to wearing a diadem, he sat on an elevated throne. The wearing of the diadem and robes identified him as a king in his own right, not only as the general of invading Greek forces. Julius Caesar would don the exact costume before he invaded Parthia many years later. Alexander even took over the 365 concubines (one for each night of the year) belonging to Darius, although it is doubtful if he utilized the harem much if at all.

Alexander also mandated the practice of *proskynesis* for his Persian allies and subjects. Long a Persian custom, *proskynesis*

was a form of obeisance a lesser person gave to one of greater social status. The payer of *proskynesis* brought his hand, usually his right, to his lips and kissed the tips of his fingers. He then blew the kiss in the direction of the king or god. Usually the payer was upright, although if he wanted a special favor or had committed some offense, *proskynesis* could be done bowing or prostrate on the floor before the king. Herodotus, the great Greek historian, described the Persian custom in this way: "When the Persians meet one another in the street, in the following way, a man can tell whether they meet as social equals. If they are equal, they kiss each other on the mouth, instead of speaking a word of greeting; if one is slightly inferior to the other, he only kisses him on the cheek; if he is far less noble, he falls down and pays *proskynesis* to his superior."[31]

Alexander's Macedonian companions tended to regard his adoption of Persian court rituals as decadent and loathsome, and they resented the entire experiment of combining Greek and Persian life and people. To them Alexander's parading around in Persian robes was disgusting. They believed the war was over, and they did not share their young king's dreams of and schemes for further eastern conquest. They wanted to go home and were saddened to see the young king they had hero-worshipped quickly turning into an eastern despot.[32]

Unfortunately for them they became so disenchanted with Alexander's "orientalizing" that a conspiracy was formed to assassinate him. The details of this plot are fuzzy, with many different versions. It seems that one of the commanders of the Companions, the cavalry of 4,000 to 5,000 armored

horsemen, a man named Philotas, instigated the plot. Philotas was the only surviving son of Alexander's chief general, Parmenion. Parmenion had been Alexander's father's primary general and had come with Alexander in the original army from Macedonia. He and his son were part of an undisclosed number of officers who distinctly disapproved of Alexander's actions.

Alexander heard of the plot from someone who told his lover who told his brother who told Alexander. This is why the information seems uncertain; however, it appeared sufficiently clear to Alexander that he held a public trial for Philotas, rather than just having him quietly poisoned. Philotas was found guilty of treason, and after a session of torture, he implicated his father in the plot. Philotas was stoned to death, and his father, Parmenion, was assassinated. Parmenion represented the conservative Macedonians at their best, and it would have been impossible for Alexander to let him live. Since he was the most powerful figure in the army, his death was certainly an object lesson to any other officers who might contemplate treasonous actions against their commander in chief.

Treatment of the masses of soldiers was somewhat different. Alexander ordered vast drinking parties and lavish feasts for the rank and file. He encouraged them to marry the concubines they had picked up on their travels, and he gave them the equivalent of eight years' pay in advance for their loyalty. The ranks of the army, even Alexander's commanders, had never imagined such prosperity.

One of the prime reasons why Alexander's army remained with him, in spite of later agonies and privations in Central Asia, was that as an aristocrat and a prince, Alexander did not believe in hoarding wealth. The army anticipated a further sharing of Alexander's hoard, and while he was never as wealthy again as when he expropriated the treasure of the king of kings, he continued to be generous to his troops. Alexander could be cruel and mean—at the slightest suspicion of treason, he would condemn a soldier to death—but at the same time he was a very generous patron.

After the execution of Philotas, Alexander placed command of half of the companions in the hands of his trusted Hephaestion, and gave leadership of the other half to a seasoned veteran named Cleitus. He was now ready to march onward to India.

To accomplish this end, Alexander relied critically on his Companions. In using this large group, Alexander was unique in the Greco-Roman world, because support for horses was a heavy burden on Alexander and his generals. It was often necessary to carry fodder for the horses along with the army. At one point Alexander was accompanied on a neighboring river by eighty lighters (storage boats) with not only food for his soldiers but also fodder for his cavalry.

Unlike cattle, which have four-chambered stomach and can regurgitate and redigest their food—chew the cud—horses, like humans, are insatiable. Hence fodder often had to be carried with the army because the terrain they were traveling in did not sustain enough grass to feed the horses. Eventually

Alexander acquired Turkestani horses, larger and hardier than his Greek ones, when battles and illness had diminished his equine army.

By the time he got his army started, however, it was winter. There was still the unfinished business of Bessus, one of the men responsible for the death of Darius. Alexander had moved into the far reaches of the empire, into what is now Afghanistan. The winter march was extremely hard on the forces; they suffered from frostbite, snow blindness, and chronic fatigue, but they reached Kandahar in February 329. Alexander allowed his men to rest for two months, and then began his march across the Hindu Kush in April.

Bessus had used a scorched-earth policy north of the Hindu Kush, but this did not daunt Alexander. Instead of taking the pass Bessus expected him to take, Alexander moved his men across the highest and most heavily snowbound one. In this way he got behind Bessus, who fled ignominiously. Alexander occupied the capital of Bactria, the birthplace of Zoroaster, and moved on toward the Oxus River. It was now June, and the desert was steaming hot; the men suffered from heatstroke and dehydration.

Some of the seasoned volunteers who had been loyal to Parmenion had had enough. They mutinied and forced Alexander to give them severance pay and bonuses and allow them to return home. They were 4,000 miles away, but they left. Alexander now found himself dangerously short of troops, so he took a gamble and enlisted locals on a large scale. After he crossed the Oxus, he received word that Bessus had been

captured and the barons responsible wanted to hand him over to Alexander. The Macedonian general Ptolemy went to pick him up and sent a letter back to Alexander, asking how he wanted Bessus brought to him.

Alexander gave specific instructions, which were carried out. Bessus—naked, tied to a post with a slave collar around his neck—was placed at the side of the road where Alexander would have to pass. When Alexander confronted him with the crime of killing Darius, Bessus admitted that he had wanted to curry favor with Alexander. If Alexander had viewed himself as a usurper, this would have been fine; but instead Alexander considered himself heir to the throne of Persia, and therefore Bessus had been the usurper. Alexander had Bessus's nose and ears cut off according to Persian custom; then he was publicly executed.

Alexander's army, which he sustained until he penetrated into Pakistan, consisted of about 50,000 soldiers, plus approximately 2,000 camp followers, including some wives and children. The people were followed by wagonloads of food and water, much of it for the horses. This additional burden of horses was later to prove too much even for the Romans. Consequently their armies comprised mainly infantry. In the Roman army only a handful of officers were mounted, so that they could strike heroic poses when the occasion demanded. But Alexander used his cavalry very effectively: They were his shock troops. By the time he reached India, however, a third of his cavalry Companions had been killed en route; they were replaced with Asians.

Alexander proceeded now to march through southern Tajikistan and northern Afghanistan into Iran, on his way to the Indus Valley in northwestern Pakistan. On this march serious fighting occurred between his forces and local tribesmen, who did not surrender easily. He garrisoned an outpost, and laid out another city, this one called Alexandria-the-Farthest. But he also sustained injuries. His leg was shot, and bone splinters kept working out of his leg for some time; he was hit in the head and neck by a large stone, an injury that temporarily impaired his vision and vocal cords and left him with migraine headaches; and he contracted gastroenteritis from drinking tainted water.

During the spring of 328, Alexander set about securing this wild territory so that his army could move on. Many of his men had been killed, and the enemy had a troublesome habit of vanishing into the steppes where pursuit was suicidal. The campaign continued to drag on with no end in sight. The enemy proved elusive, and each foray left more Macedonians dead.

Anger and frustration continued to grow between the original Macedonian troops and the newer Asian recruits, drinking parties abounded, and tempers were lost nightly. One such eruption proved to be disastrous for the entire army.

It was a particularly hot night—reminiscent of Philip's wedding night, when he and Alexander had their angry confrontation—and Alexander had been drinking far too much, as had everyone at the party. Alexander started bragging about his exploits, seeming to forget that an entire army

had helped him. Cleitus, the commander of half of the Companions, took exception to Alexander's egotistical attitude, and told him that without his Macedonians he would have gotten nowhere. The party divided along the sharply delineated lines that had been there since the death of Parmenion—the old guard versus the new Asians and the simplicity of old soldiers versus the sophistication of the new army. Suddenly Alexander grabbed the first thing he could find, which was an apple, and lobbed it at Cleitus's head. He looked around for his sword, at which point several courtiers restrained him while others got Cleitus out of the hall.

Cleitus broke free and ran back inside, shouting a line from Euripides, "Alas, what evil government in Hellas!" Alexander grabbed a sword from one of his guards and stabbed Cleitus to death. Alexander regretted his actions as soon as he sobered up. He refused food and drink for three days, and ordered a huge state funeral for Cleitus, but the damage was done. From then on there was always an element of distrust between the old army and the new one. The Greeks, for their part, realized that they were thousands of miles from home and that the only person who stood between them and annihilation was Alexander. They needed to make their peace with him.[33]

Tajikistan and Afghanistan were then much as they are now, tribal societies with strong kinship bonds. It was a world of warlords. (The prime difference between Afghan society in the fourth century BC and Afghan society today is the absence in antiquity of the opium trade. It was the British in the 1840s

who got the Afghans to cultivate this drug cash crop, which they British then exported to China.) The warlords' bands and families offered only moderate resistance to Alexander.

One particular stronghold, known as the Soghdian Rock, was controlled by a warlord named Oxyartes. The rock itself was considered impregnable, so Alexander offered rewards to the first twelve men who could scale the sheer cliffs behind the fortress. When the men got to the top, they were to wave white flags. About thirty fell to their death during the night climb, an awesome task even with modern equipment, but at dawn white flags were seen from below. Oxyartes was so flabbergasted at the presence of Alexander's men on his rock that he immediately surrendered his fortress.

That night at a banquet, Alexander met Oxyartes' daughter for the first time. Roxane was considered the most beautiful woman in Asia, with the possible exception of Darius's wife. It is doubtful if Alexander fell head over heels in love, as has been suggested in some fanciful romances since, but he saw the expeditious advantage in marrying her. So there, on the outskirts of the known world of the time, the most eligible bachelor in the world married the most beautiful woman in the world. It appears that she accompanied him into India and bore him two children. To add a little irony to the situation, Hephaestion was his best man.

Then, in the outback of Iran, Alexander decided to try an experiment that he had obviously been toying with for some time, and that once and for all indicated to the Macedonians what their king had in mind. He decided to try out the

practice of *proskynesis* on his Macedonian friends. Since the king was superior to everyone, everyone had to pay him *proskynesis*. The Greeks, who had been in the habit of giving this sort of worship only to their gods, had always had trouble bowing and scraping before mere mortals. To the Persians it was a matter of etiquette; to the Greeks it was confused with homage owed to the gods. This leads to the conclusion that Alexander's deification was in his mind only, and that his men still considered him just a great man.

Alexander decided to try the *proskynesis* experiment out at a banquet. It started like any Greek banquet, with toasts and the cup of wine passed from hand to hand. All Alexander's intimate friends were aware of what the king wanted from them, and they decided to humor him. After they had drunk from the libation cup, they kissed their fingertips and gestured toward Alexander. They then approached him and he kissed them in return; this kiss was tantamount to saying that he had accepted their fealty.

When Callisthenes, who was the court historian and Aristotle's nephew, approached the king, he omitted the *proskynesis*. Alexander refused to kiss him. Even though Callisthenes, in his official history, allowed Alexander a divine nature, actually demonstrating it in public was apparently more than he could stomach. He believed that paying *proskynesis* to a mere mortal was degrading and inappropriate.

Not long after this unfortunate incident, a serious plot was discovered against Alexander's life. A group of Macedonian boys about fifteen years of age had been sent out to join the

army as pages. A hunt was in progress, and one of the boys got to the boar ahead of the king and delivered the killing blow. Considering that his royal prerogative had been flouted, Alexander ordered the boy beaten. The page now had a distinct grievance, and he persuaded seven other boys to join him in a plot to assassinate the king.

This would actually have been a rather simple task, because the pages were sometimes the only ones on duty at night in Alexander's tent. They had a rotating schedule, and sooner or later the conspirators would be there in large enough numbers to overpower the sleeping king. The only problem was that Alexander rarely came to bed before dawn, which was also when the guard changed. The night of the planned attack, Alexander was later than usual coming to bed, the guard had changed, and the page on duty knew of the plot. He told his current boyfriend, who told his brother, who told two bodyguards, who told Ptolemy—and hence the word got back to Alexander.

When the pages were questioned, it was learned that the teacher of one of them was Callisthenes, and he was implicated as the adult who had instigated the entire assassination plot. Since Alexander resented Callisthenes anyway for his singular opposition to *proskynesis*, he had him arrested, tortured, and put to death. How this played back in Athens is unclear.

Alexander's picture of India was strange, to say the least. The Greeks of his day, and Aristotle in particular, believed that India was a shallow peninsula bounded on the north by the Hindu Kush and on the east by the ocean. They had no

knowledge whatsoever of China or Malaysia or any lands farther to the east. This lack of information made India Alexander's breaking point, as Russia would prove to be centuries later to Napoleon Bonaparte. For the present he seemed to have been motivated by curiosity about the unknown and a burning desire to be lord of the entire world as he saw it.

He marched out at the head of his army into the great unknown with confidence and dreams of grandeur. It is hard to estimate accurately the size of Alexander's army as it headed into India. According to Green,

> Alexander had with him not more than 15,000 Macedonians, of whom 2,000 were cavalrymen. Total cavalry estimates, however, range between 6,500 and 15,000. The infantry figures are equally uncertain, varying from 20,000 to 120,000. Tarn's guess of 27,000–30,000 operational troops is almost certainly too conservative. On the other hand it has been suggested, with some plausibility, that 120,000 represents an overall total, including camp-followers, traders, servants, grooms, wives, mistresses, children, scientists, schoolmasters, clerks, cooks, muleteers, and all the other members of what had by now become "a mobile state and the administrative centre of the empire."[34]

With this army, he fought against the tribal barbarians. But he did not need an embodiment of the enemy. The sheer

physical task of climbing mountains, going through narrow defiles, and encountering terrible thirst and hunger in the desert—this was challenge enough. If the tribal barbarians crossed his path, so much the better. He could cut them down and leave bodies in the mountain passes and in the desert to be bleached by the pitiless East Asian sun or eventually to be covered by sandstorms.

On the border of Pakistan and Afghanistan, Alexander encountered stiff resistance. He was now on what the Victorian British called the fearsome North-West Frontier. He was moving down toward the Punjab in the Indus Valley. The British in the nineteenth century had mixed experience fighting in these difficult areas. So did the Russians in the twentieth century and the Americans in the twenty-first. And so did Alexander. Afghanistan remains today, as it was in Alexander's time, a graveyard for soldiers.

Across Tajikistan, across Afghanistan, and down into Pakistan his army moved, by now living mostly on what the land produced. Rarely in the history of antiquity, with its tortuous wars, had an army as dedicated and determined as the one that followed Alexander assembled and thrust forward into the unknown. There was no strategy except the attraction of far-off, fabled India. Alexander himself had taken command of what had been Cleitus's half of the remaining companions, and Hephaestion commanded the other half.

One of the most interesting details of this campaign was the introduction of elephants to the West. These animals could be

used in battle, their tusks sharpened and laced with poison; they could also be used to fell trees to build roads and encampments. Alexander was the first Western commander to do serious battle using elephants. He was so impressed with them that he sent them back home with their trainers, the *mahouts*. Eventually they found their way to Carthage and thence into the army of Hannibal, who used them with great efficiency to terrify Roman forces. Horses were scared of elephants and usually bolted at the sight of a line of elephants approaching them—a problem that filled Alexander with some apprehension.

For these reasons, Alexander was gratified to hear that several local rajahs were coming over to his side, along with twenty-five war elephants. He was warned that an adjoining Indian prince by the name of Porus was well armed and would undoubtedly oppose him. Envoys were sent to Porus asking him to come to meet the Macedonian king and bring tribute. Porus replied that he would come, but the only tribute he would bring was his army. War was the only recourse left to Alexander at this point.

Alexander and Porus faced each other across the Hydaspes River. Alexander had to cross the river with his army in one way or another. Porus himself sat on his horse in front of his army and his force of elephants waiting for the Greeks to cross. His intention was to slaughter them as they came out of the water. The elephants bothered Alexander the most because he knew that if he crossed the river there, his horses

most likely would refuse to leave the water and would turn around and create chaos.

Eventually, Alexander split his army and crossed, but he was met by the son of Porus. Alexander was wounded in this skirmish and Bucephalus was killed. But the Indian army, seeing Alexander himself at the head of the cavalry, turned and ran. Alexander personally pursued Porus's son and killed him.

Porus had an immense army consisting of some 30,000 cavalry, 300 chariots, 200 elephants, and 30,000 infantry. His strategy was to bring the elephants up into the battle, hoping they would intimidate the horses and force the Greek army to attack between elephants. His infantry was stationed between the elephants and on the wings beyond the elephants.

When Alexander saw the battle formation of the opposing army, he decided that heading for the center would be suicidal, and because he believed his cavalrymen were superior, he took most of them and rode to the left with 1,000 archers on horseback. Porus never expected that his own formation would break, but when the archer cavalry attacked, the Indian cavalrymen were facing in both directions. They fell back in disorder among the elephants. The Macedonian phalanx marched toward the elephants, attacking the *mahouts* and subjecting the elephants to volleys of weapons from all sides.

The elephants panicked, and as they twisted and turned, they trampled their own men as well as those of Alexander. Eventually most of the drivers were dead or injured, and the

elephants were exhausted and driverless. Finally, they retreated in haste.

Porus had lost some 23,000 men; all his chariots were destroyed; two of his sons were killed; and the captains and generals of his army were dead as well. Unlike Darius, however, Porus chose to stay in the field. He attempted to bring some semblance of order among his men and urged them to keep fighting. He turned from the field only when he himself was wounded.[35]

Alexander admired Porus and his greatness in battle and wanted him kept alive. When Porus rode toward him as if to surrender, Alexander was amazed at the man's size. He stood about seven and a half feet tall and was very handsome. He refused to be cowed and, in fact, seemed to act like an equal meeting an equal after a great battle, rather than like a defeated foe. Alexander asked Porus what kind of treatment he wanted, and when Porus asked to be treated like a king, Alexander was so impressed that he not only allowed Porus to live but granted him sovereignty over the Indians of his realm and added more lands to what he already had. In this way, he made an ally out of his fiercest adversary. From then on, Porus was completely loyal to Alexander.[36]

After this fateful battle Alexander allowed his men the luxury of a month's vacation, during which time he gained more men, sent Porus to get more elephants for him, and in general gave the impression that renewed attacks were being mounted somewhere else. A few minor skirmishes gave Porus more

territory, and he was content to help Alexander with the latter's plans. It was not the same with the Greek and Macedonian troops, however They were near the breaking point—tired of the whole thing and ready to go home. So far their obedience, discipline, and loyalty had kept them going, along with the desire for plunder, but there was no clear end in sight. Their sense of adventure and exploration of the unknown for the sake of adventuring had never been their vision; it had been Alexander's.

His men had marched 11,250 miles in eight years, regardless of the season or landscape; official figures were to claim that they had killed at least 750,000 Asians. Twice they had starved, and their clothing was so tattered that most were dressed in Indian garments; the horses were footsore and the wagons were unusable in plains that had turned into swamps. It was the weather that had finally broken their spirit. For the past three months, the rains had doused them through and through. Their buckles and belts were corroded, and their rations were rotting as mildew ruined the grain. Their boots leaked, and no sooner had their weapons been polished than the damp turned them green again with mold. And the river Beas rolled on before them, defying them to cross it in search of a battle with elephants, not in tens or hundreds but in thousand upon thousands.[37]

Torrential rains brought snakes inside—pythons, scorpions, and cobras—the size of which the Greeks had never seen before. Between the monsoon, the snakes, and the fear of encountering

more elephants, the Macedonians rebelled. In what is today northwestern Pakistan Alexander delivered a grand speech to his army urging them to press on into India. Alexander stated:

> In my case, there is no part of my body—not at the front, in any case—that has been left without a wound, and there is no kind of weapon, be it for hand-to-hand fighting or throwing, whose scars I do not have on myself. I have sword gashes from hand-to-hand fighting, arrow wounds, injuries from artillery projectiles; and I have been struck in many places by stones and clubs. All this for you and your glory.[38]

For once his eloquence and charisma failed to rouse his troops to follow him any farther. Once they had crossed the Beas, they were at the end of the world as the Greeks knew it. Rumors abounded about the ferocity of the people on the other side. These people had 4,000 fighting elephants and thousands upon thousands of men, all younger and more energetic than Alexander's. One of the old soldiers, a man named Coenus, who was dying anyway, got up the nerve to address Alexander. He gave the speech of his life, ending with these words: "Sir, if there is one thing above all others a successful man should know, it is *when to stop.*"[39]

Alexander sulked for two days but then tried to find a way to make this defeat appear to be a victory. He had never faced

defeat before, and it was not something he dealt with easily. As he had always done before a battle or a major decision, he called his seers and prophets. For once the omens went against him, so with face-saving aplomb, Alexander bowed before the will of heaven, definitely not his men. Twelve great altars representing the twelve Olympic gods were built beside the river, and after sacrifices were made, he announced that they would be going home. His soldiers laughed and cried and, hysterical with relief, called down blessings on his head. For his part Alexander never got over his humiliation and never forgave the men who led the revolt.

The expedition ended a mere six hundred miles from its goal—the ocean, which would have been the end of the earth. Because of faulty geography and poor military intelligence, Alexander never knew this. It was probably a good thing. His dream was gone.

FOUR

The Last Years

\mathcal{A}LEXANDER STARTED home in the fall of 326. For his veterans, home was Macedonia; for Alexander it was Babylon. He never stepped on Greek soil again, nor did he ever appear to want to.

The army marched back to the Jhelum River, where a naval flotilla awaited them. These ships had been built earlier with the intent of pursuing conquest down the Ganges, but they were now to be used to carry the army home. Reinforcements arrived, along with medical supplies and clothing. Before the departure the eloquent Coenus died, giving rise to the idea that anyone who courted Alexander's displeasure would not live long.

At this point the Jhelum was about two and a half miles wide, so the flotilla was able to travel with forty oared galleys abreast. Natives ran along the banks, and sometimes even joined the parading troops. Hephaestion was on one side of the river with the main body of troops and two hundred elephants; his archenemy, Craterus, was on the other.

The first difficulty arose with the fast current and whirlpools where the Jhelum met the Chenab River. The light galleys bobbed around like corks, and oars snapped in the current. The flagship, carrying Alexander, nearly sank, and he, who could not swim, was barely saved.

Reports came that two tribes were massing for an attack to stop the flotilla's advance. The men were so demoralized by the news that they would have to fight again that it took all the inspiration Alexander could dredge up to get them to go into battle. Twice they refused to go up scaling ladders against an armed fortress, and Alexander was so annoyed with them that he led the way personally and shamed them into following him.

For once the soothsayer-in-residence went against Alexander and warned him that he would be injured if he continued with this assault. Alexander is supposed to have responded, "If anyone interrupted *you* while you were about your professional business, I have no doubt you would find it both tactless and annoying, correct?" The seer agreed. "Well," continued the king, "*my* business—vital business—is the capture of this citadel; and I don't intend to let any superstitious crackpot stand in my way."[1]

The king proceeded to command that scaling ladders be brought up to the walls, and he went up the first one himself. He killed the first two defenders and then foolishly but daringly jumped inside the battlements: He was a perfect target for an archer. His men, following his lead, climbed the ladders in such numbers that the rungs collapsed, causing many soldiers to fall to their deaths. Alexander was temporarily cut off from the bulk of his forces. He and three of his aides fought courageously but alone. A long Indian arrow suddenly pierced Alexander's armor and entered his chest just above his lungs.

He was carried off the field more dead than alive. Indeed, rumors spread quickly that he was dead. The arrowhead, about three inches long, was leaf-shaped and barbed, and getting it out was a very dangerous procedure. A major hemorrhage followed, and Alexander lost consciousness. He hung perilously between life and death for a week. The Indians, believing the rumors, attacked with renewed ferocity.

Even after he regained consciousness and sent a letter to his troops that he was fine and would soon be up and around, they refused to believe him. So great was his physical presence that they could not conceive of going on without him. This was later proved true when, upon his death three years later, his empire fell into shreds and infighting among his closest companions lost all that Alexander had gained.

He was going to appear in front of his troops in a litter, but it soon became apparent that the men needed to see him

mounted on his horse, ready to do battle again. Even though he was still extremely weak, and the wound had still not healed, Alexander mounted his horse and rode through the ranks of soldiers, who waved and cheered and touched his clothes with almost religious fervor. He never completely recovered from this wound, and after his friends harangued him about his foolhardiness, he promised that he would be more careful in the future.

On the downside Alexander must have believed that his recovery was such a miracle that he was never to be crossed. He was now able to get away with anything, and in his own mind this rendered his concept of deification more powerful, until it became an obsession.

More battles followed as the entourage made its way down the Indus River. Some of the Indian rulers surrendered without incident; others insisted on fighting. Some casualty figures that have been given are as high as 80,000; and the actual number may be even higher.[2]

Alexander failed to achieve a lasting place in Indian history and literature. He was viewed in his own time as an invader and a destroyer, not an empire-builder. This could not have been his ambition. In reality, Alexander was only a precursor of other conquerors, such as Sultan Mahmud, Tamerlane, and Nadir Shah, who were more successful in massacre and plunder than Alexander had been.[3]

One story is told by Arrian that illustrates what the Indian wise men and philosophers felt about Alexander. He found the wise men in a meadow, and when they saw Alexander,

they did nothing further than beat with their feet the ground on which they stood. When Alexander inquired through interpreters what this action of theirs meant, they replied: "Oh, king Alexander, each man possesses just so much of the earth as this on which we stand; and you being a man like other men, save that you are full of activity and relentless, are roaming over all this earth far from your home troubled yourself, and troubling others. But not so long hence you will die, and will possess just so much of the earth as suffices for your burial."[4]

In order to get the army back into home territory, Alexander decided to split the troops. The fleet would continue from the Indian Ocean into the Persian Gulf, and he would take the bulk of the army and noncombatants home though a wilderness known as the Makran. He set men to the task of planning for the victualing of the fleet, leaving supplies of food and water at outposts along their path. Why he chose the more dangerous path for the rest is uncertain. It has been suggested that he had to keep the territory subdued for the passage of supplies. The primary territory bordering on the Makran was Gedrosia, and this is where Alexander turned his army. He tried to keep as close to the shore as possible, but the terrain was still desert. Though he had advance parties digging wells so a water supply would be available, this eventually became impossible after they entered a mountainous section near the coast. The army had to detour far inland.

Lack of water now became a serious problem. The army often had to march fifty miles to find a pool of even brackish

water, and then the men would jump in, armor and all. Sometimes they would die of overdrinking after being dehydrated. Heatstroke was also a possibility.

The army traveled laboriously through sand dunes, where their wagons sunk to the axles and their boots filled with grit. Their faces were constantly tormented with stinging sand and insects. Poisonous snakes and plants were all around them. A type of prickly cucumber squirted a juice that caused blindness, and some shrubs made the pack animals foam at the mouth and then die.

Sometimes too much water caused disaster also. Flash storms from the hills occasionally roared through the night darkness and carried everything away in their path. One such flash flood killed almost all the women and children, and the soldiers survived with nothing but the clothes they were wearing and their weapons.

It took the columns sixty days to traverse the Makran, and after getting lost in a blinding sandstorm, the gaunt skeletons that had been Alexander's army emerged. This disastrous march through the desert has been compared to Napoleon's retreat from Moscow in 1812. The losses were staggering. Perhaps 85,000 people started into the desert; only about 25,000 survived. Alexander's horses, equipment and supplies were all lost, as were the majority of the non-combatants in the army.[5]

Alexander needed an explanation as to why his supply trains and reinforcements, carefully planned for in advance,

had not appeared on schedule. Although he had become more paranoid as time went on, in this instance he probably had good cause to wonder.

The first person to suffer the effects of Alexander's fear and paranoia was a man named Apollophanes, who was the satrap of Gedrosia. He was killed before he could be brought before Alexander for an explanation as to why he hadn't supplied the king adequately. From all sides now came reports of gross incompetence, insubordination, and corruption among those who had been left in power in Alexander's absence. Reports of his demise in India had come through, and many of the men in power had decided to set up their own little kingdoms while he was gone. Such little pockets of power were hotbeds of sedition and treason, as Alexander well knew. He had to take action quickly to save not only his kingdom but his life.

Thus began a purge of the satraps. No fewer than five leaders were tried and executed in short order, so that when Alexander ordered his remaining satraps to disband their personal mercenary forces, they did so.

It was December 325 before the fleet finally appeared, intact, giving rise to great rejoicing. The troop had battled unfriendly tribesmen, survived a school of whales that seemed intent on upsetting the ships, and been forced to eat their camels, but they had it much easier than the land force. To celebrate, Alexander ordered days of athletic and musical festivals to thank the gods for the safe return of his fleet.

According to Green and other sources, after Gedrosia a change took place in Alexander—and it was not for the better. He became increasingly paranoiac and suspicious of everyone, willing to listen to whatever gossip was told him about his officials. He would punish minor offenses as if they were serious ones, often overlooking the serious ones in the process. The sources of antiquity seem to be united in the opinion that Alexander's character had undergone very considerable degeneration. From the beginning (witness Thebes and Tyre) Alexander had been murderous when thwarted in his desires. But in this instance absolute power had corrupted absolutely, and the combined effects of unbroken victories, unparalleled wealth, absolute and unchallenged power, continual heavy physical stress, and incipient alcoholism had taken their toll. As a young man Alexander had been abstemious; now he regularly drank to excess. He had become a domineering and uncontrollable megalomaniac, and very dangerous.[6]

But temporarily, at least, his anger and spite had run out; he suspended his purge and, when he returned to Susa, turned his attentions to other things. There was talk of other campaigns—to Carthage, Spain, Italy, and Saudi Arabia. He set his admiral, Nearchus, to work building seven hundred new war galleys. And controversially, he set about to orientalize his kingdom. He started by assimilating Persian generals into his command and creating a joint Persian-Macedonian group of administrators.

Years before Alexander had sent 30,000 Iranian boys to Macedonia to be given military training, and these boys were now back. They were young and bursting with enthusiasm, while Alexander's staunch troops were now tired and aged. These Iranian boys created tremendous resentment among Alexander's seasoned veterans, who believed that Alexander had been destroyed by the East. His adoption of Persian clothing and his autocratic behavior did nothing to dispel their fears.[7]

A further irritation for the Macedonians was an attempt of Alexander's to integrate the Persians and Macedonians in a personal way. He decided to hold a mass wedding, celebrating for five days the marriages of ninety-one of his Macedonians to highborn Persian women. He himself took two wives—the eldest daughter of Darius III and the youngest daughter of Artaxerxes III. He gave another bride to Hephaestion, because he wanted their children to be cousins. The celebration lasted five days and was colossally expensive. Alexander spared no expense. He gave the women huge dowries, furnished a bridal chamber for each couple, and had the banquet served with the guests seated on couches with silver legs.

There is no indication that any of these marriages succeeded; in fact, most of the women were summarily divorced within months of Alexander's death. It was another experiment that failed miserably.

In the spring of 324, Alexander led an advance party down the Tigris River, obviously intending to pave the way for an

invasion of Saudi Arabia. The group found many dams along the way, which were for the purpose of subverting the waters into irrigation channels. Wherever they found these, Alexander ordered them destroyed. The agricultural well-being of the area was secondary to making the river wide enough for his ships to sail southward.

Alexander went further, announcing that all the old, seasoned soldiers in the army were going to be retired and sent home to train new recruits in Macedonia. These were same troops who had revolted at the Beas River when they refused to go any farther, and now they took their retirement as an insult. Alexander saw their discontent as a challenge to his authority. He was walking around in his purple-and-white Persian robes with the royal diadem on his head, receiving *proskynesis* from his Asian subjects with no difficulty, having no one gainsay his word on anything. For his veterans to complain was too much.

Alexander ordered the most obvious demonstrators to be arrested and immediately executed. Then he went into his quarters and secluded himself for several days. Rather than capitulate to the demands this time, he removed all his Macedonians from their commands and gave those commands instead to Persians. Not only could Macedonians now be replaced by Persians; they might actually be *disciplined* by Persians. In response to this threat, the Macedonians gave in completely and begged Alexander for forgiveness, which he graciously gave, but not until extreme homage was given and a lot of

groveling was done. Then a huge banquet was held to celebrate the reconciliation, and the Macedonians continued to hold high command.

Ten thousand Macedonian veterans were now sent home, paid handsomely, and put under the command of Craterus. Craterus was to go back to Macedonia and relieve Antipater as regent, the latter to join Alexander in Asia with a fresh army of recruits. As far as Alexander was concerned, Antipater had been causing trouble back home; letters from Olympias had strained the relationship between the two men, and Alexander obviously felt it would be better to have Antipater closer to the court.

Antipater at first refused and sent his son Cassander instead. Alexander had a deep antipathy toward both Antipater and Cassander (he was very intuitive where his intimates were concerned); that is why they were the primary suspects when rumors that Alexander had been poisoned erupted after his death.

Alexander now moved his court to the ancient Persian summer palace in Ecbatana, where the time was spent in festivities and drinking parties. It was at one of these that Hephaestion took ill; he died seven days later. The influence of this man on Alexander cannot be overstated. He had been Alexander's closest friend and lover since boyhood, was the only person who consistently supported him in all his exploits and decisions, and was second only to Alexander in power. Even the eunuch Bagoas, who was Alexander's favorite also, never came close

to the influence wielded by Hephaestion. Hephaestion had apparently never overstepped his privileged friendship, and Alexander was devastated by his death. In fact, he never recovered from it.

Autumn turned to winter, and according to Plutarch, Alexander sought to "alleviate his grief in war, [and] set out, as it were, to a hunt and chase of men, for he fell upon the Cossaeans, and put the whole nation to the sword. This was called a sacrifice to Hephaestion's ghost."[8]

Early in 323 the court made its way back to Babylon. Alexander had been warned by his seers that he should not go into Babylon, or if he did, at least to approach the city from the east, not the west. He apparently took the warning seriously, as he was wont to do, and attempted an easterly entry. But he found this direction blocked by a marsh, so against the advice of his religious advisers, he entered from the west.

Once he was in the city, he received numerous delegates from all over the Mediterranean, bringing felicitations and gifts. Rulers from as far abroad as Spain had heard rumors that Alexander was planning an offensive against the West, and they wanted to be the first to get into his good graces. If a delegation came from the Roman republic, it would have been fraught with symbolism, but the Roman consuls, busy with the Samnite Wars and soon to be at war with Carthage, were not really worried by this "conqueror of the East." Alexander was more involved and preoccupied with the

approaching invasion of Arabia, which was never to come to fruition.

The last ten days of Alexander's life are somewhat shadowy in content. The rumors that he was poisoned arose because his death occurred so quickly, and no one could die that quickly unless he was poisoned—or at least that was the wisdom of the day. More likely, he developed a fever (perhaps malaria), but he continued to attend banquets still being given in honor of Hephaestion where drinking was heavy. One night he is supposed to have drained a glass of undiluted wine, twelve pints in capacity.[9]

He took his usual bath each morning, made his customary offerings to the gods, and continued to drink each night. The fever intensified over the ten days, and eventually he lapsed into a coma. He died on June 10, 323 BC, without leaving any clear-cut directions for his succession. He was thirty-three years old. The exact location of Alexander's tomb is unknown, but some sources claim he was buried in Alexandria in Egypt.

Alexander's frenetic behavior in the last two years of his life indicated that he was suffering from mania and paranoia and was probably clinically insane. Plutarch provides this somber account of Alexander's death:

> Oracles from the god relating to Hephaestion were
> brought to him, and after that he put an end to his

grieving and went back to his sacrificing and drink-
ing. He gave a magnificent banquet for Nearchus,
and afterwards took a bath, as he usually did when
about to go to bed, but then, pressed by Medius, he
went to continue the party in Medius' tent. There
he spent the whole night and the next day drinking,
during which he began to develop a fever. He did
not drink the "cup of Heracles" nor did he suddenly
feel a severe pain in the back as if he had been
struck by a spear, though some authors think they
should add these details as a way of fashioning a
tragic and highly emotional finale to a great drama.
Aristobulus simply states that Alexander developed
a high fever and that his raging thirst made him
drink wine, after which delirium set in and he
died.[10]

This account is consistent with alcohol poisoning, aggra-
vated by malaria.

Before these last two years of ill health, dissipation, and
madness, Alexander had done enough to make a reputation as
the cynosure of antiquity, its supreme hero. It is true that
Alexander was fortunate in the weakness and incompetence of
his enemy Darius III. It is also true that Alexander ran into
stiff resistance from the princes of the Punjab; he was not in-
vincible. But what gained Alexander his posthumous reputa-
tion was the kind of man he was, irrespective of military
strategy and tactics.

He was like those athletes at the quadrennial Olympic Games who stripped naked and covered themselves with olive oil. He, too, stood before the world naked and fierce, a beautiful man among other beautiful men, but with incomparable capacity for leadership and for showing the world his strength, intelligence, and guile.

FIVE

How "Great" Was Alexander?

*F*OR ALL practical purposes Alexander's empire died with Alexander. His only brother was feeble-minded, and his only heir was a baby. Neither was in any position to assert authority. But practical considerations aside, Alexander moved quickly to become a symbol of conquest. He gave a semblance of legitimacy to anyone who might desire conquest, regardless of how inherently wrong that conquest might be. He was a pioneer in bringing Europe and Asia together into discourse and commerce.

It appears as though he did this empirically, administering the Persian Empire peacefully while he moved beyond its borders into India. Perhaps he would have undertaken some

systematic reorganization of his empire, stretching all the way from Macedonia to northern India, but he did not have time to do this.

Alexander's effort to create a world state and empire were less successful. Within a decade of his death, his kingdom, loosely organized as it was, split apart. His successors, who were his generals, carved out territories for themselves. Cassander took Macedonia; Seleucid took most of Asia Minor, Syria, Iraq, and Iran; Ptolemy took over Egypt. In Egypt Ptolemy—who wrote an account of Alexander's military campaigns—established a dynasty that endured until 30 BC, ending only with the defeat of Mark Antony and Cleopatra by Julius Caesar's grandnephew Octavius (later Augustus Caesar) at the Battle of Actium.

Experts on Alexander's life are divided on some issues concerning events, and how to separate fact from legend. A man such as Alexander obviously is going to be the stuff of legends; it is inevitable. As was the case with both the Greek and the Roman aristocrats, Alexander was, by our standards, a cruel man. His army suffered 50 percent mortality. The mayhem he inflicted on his enemies in battle reached catastrophic proportions. A safe estimate is that half a million soldiers and sailors were wiped out among his enemies. The losses in his own armed forces during a decade of battle were in the neighborhood of 25,000. Eventually he could not rely on reinforcements from Macedonia (it had been stripped clean) or even on southern Greek mercenaries. At the time of his death at least 40 percent of his army consisted of Persian soldiers.

In addition to this mayhem against military forces, Alexander sold probably 500,000 people, at least half of them women and children, into slavery. This was the common fate of defeated cities in Greek and Roman times. It was the law of war. If a city fell, especially if it dared to resist, the inhabitants were sold into slavery. It had been that way for Alexander's father, Philip, and it was the same for Alexander, but on a grander scale.

Alexander was hard not only on his enemies. His treatment of his own generals and other officials was draconian. His best general, Parmenion, was executed or assassinated at Alexander's behest because Alexander became suspicious of Parmenion's complicity in a plot involving the general's son. There exist stories regarding the removal and execution of courtiers and officials for what seem to us fully pardonable offenses. The two Persian officers who had killed their emperor were themselves hunted down and murdered in turn—Alexander said he was the emperor's successor and sought revenge on his killers. Alexander murdered one of his best friends and drinking companions by his own hand after the latter had taunted and annoyed him. At least in this case, Alexander is said to have shown great remorse.

Like most men of his time, Alexander considered life cheap. He made his way across Asia trailing blood. Charity and mercy were not behavioral qualities of the gods of ancient Greece, nor was Alexander inclined in that direction. Besides this lack of divine models, Alexander had a very quick temper: Anyone who crossed him he sought to cut down immediately.

At the other side of the moral ledger, Alexander was a very brave man. He personally led his troops and amazed even his enemies with his almost superhuman feats. He suffered at least four major wounds, coming close to death on two occasions. He shared rations with his soldiers, and at times of water scarcity in the army he refused sustenance. We are told that Alexander did not condone rape, but looting was intermittently allowed in addition to his soldiers' very high pay. One story is told that on the final march through the Makran, one of his soldiers found some good water and brought it personally to Alexander in his helmet. Alexander thanked him but then dumped it on the ground, saying that if his men could not have water, neither would he.

He led his soldiers across deserts and over mountains, into places no one else would dare go. Coming up against elephants for the first time in northern India, he was in no way fearful, but plunged ahead as he had always done.

Also, Alexander was lavish in rewarding his soldiers and sailors, especially those who had accompanied him initially from Greece.

Alexander was very courageous and a charismatic leader of men, but was he a great general? The resounding answer has been yes. In fact, a recent book makes him out to have been a model corporate executive:

> The life and personality of Alexander were highly
> complex. . . . These distinct beads [in the necklace
> of Alexander's life are] posited around real issues we

confront today: How do we develop and train professionals? How do we think about basic issues in strategy such as where, when, and how to compete? How do we handle leadership transitions? How do leaders assert authority in their "First Hundred Days"? Why do leaders single out myths? What are the many styles of leadership a single person can possess in [his] quiver and which to choose where and when? How should we be thinking about convergence of cultures and divergence of social mores as we seek to expand the footprint of our influence? How does one think about what to carry and what not to carry on a campaign? What role does strategic deception play in competitive situations? Why is a leader's legacy such a delicately balanced equation that often totters on the verge of falling off a pedestal? These are the questions we focus on as we study the life of Alexander.[1]

As a matter of fact, Alexander would not have made a good modern corporate executive. He was too headstrong, too impetuous, too intuitive. He was a general, a military leader. He judiciously managed his regiments, knowing when to engage in frontal assaults and when to use flanking movements. Again he was similar to Napoleon, except that Alexander always personally led his army from its front rank.

It was in the skillful use of infantry that Alexander's armies excelled. This was the key to Alexander's success—the skill

and discipline of his infantry and the wielding of *sarissas*. It required a great deal of training and much discipline to make these long pikes effective. The Romans later would use their infantry in much the same way and conquer the world.

One of the first accounts honoring Alexander after his death comes from a Roman source of a supposed conversation between Scipio Africanus (who destroyed Carthage) and Hannibal in Ephesus. Africanus asked who Hannibal thought had been the greatest general, and Hannibal replied that it was King Alexander of Macedon, because with a small force he had defeated armies of immense proportions and penetrated to the ends of the earth, which human beings had never expected to visit.[2]

The Romans were the first to honor Alexander by imitation. Bosworth tells us:

> Pompey, whose very name (*Magnus*) evoked the Macedonian conqueror, notoriously modelled himself upon Alexander from his boyhood, adopted Alexander's mannerisms and patently saw himself recreating his conquests in the east. The same applied to Trajan, who sacrificed to Alexander in Babylon, and in conscious imitation, sailed down the Euphrates to the ocean, reporting in his dispatches that he had gone further than the Macedonian king. With Caracalla imitation became a mania, to the extent that he recreated a phalanx of

Alexander, entirely Macedonian in composition and equipped with the authentic armament of the period.[3]

Pompey's opponent Julius Caesar was often compared to Alexander, first by Plutarch, and later by others. Although Caesar's conquests were more political in nature, he used Alexander's mixture of infantry and cavalry to great advantage. A story is told that once when Caesar was in Spain and at leisure, he was reading a history of Alexander. He was lost in thought and then burst into tears. When his companions asked him what was wrong, he answered, "Do you not think it is a matter for sorrow that while Alexander, at my age, was already king of so many peoples, I have as yet achieved no brilliant success?"[4]

Mark Antony could not have avoided thinking of Alexander as he married the last of the Ptolemaic pharaohs, Cleopatra. He named his son, fathered on her, Alexander. Octavius (Augustus Caesar) visited Alexander's grave after he defeated Mark Antony and Cleopatra and entered Alexandria as a hero. Caligula supposedly removed Alexander's armor from his tomb and wore it for state occasions.

Truth to tell, however, Alexander was fortunate against his enemy—the Persian emperor, Darius III, was a reluctant soldier. He fled from the field of the two great battles that Alexander fought against him, disheartening and dismaying his troops. Darius was slow to react when Alexander conquered

Asia Minor and Egypt, and encountered the great Alexandrian threat only along the eastern frontier of Asia Minor. He could have put in the field an army of at least 100,000 but never did so. Darius III eschewed a scorched-earth policy that would have left Alexander's troops very hungry. He failed to protect his vast treasury in Babylon and Persepolis, allowing it to fall into Alexander's hands.

With a relatively small army, although highly disciplined and for the time well armed, Alexander showed that he was a superb field commander who could maximize his resources. Against the Romans the result possibly would have been different. In fact, the famous Roman historian Livy, writing in the late first century BC, was positive that Alexander could not have defeated the Romans. He declared:

> "[At] the outset I do not deny that Alexander was an outstanding leader. His reputation, however, was boosted by the fact that he was acting alone, and also that he died in his youth as his career was taking flight and when he had experienced no reversal of fortune."[5]

He goes on to say that the Roman Senate and its generals would have been much harder to defeat than was the effete Darius. Italy would have been a different proposition completely. Because success changed him, Livy goes on to say, Alexander would have come to Italy more a Darius than an Alexander, and brought an army that had forgotten Macedon

and was already lapsing into Persian ways. Alexander had a violent temper, killed many of his friends while in the throes of drunkenness, and made ridiculous exaggerations about his parentage. A young man would have had no success against a nation already seasoned by 400 years of warfare. It is not difficult to see where Livy's sympathies lay.[6]

It is one of the ironies of ancient history that a writer who lived five hundred years after Alexander should be regarded as a trustworthy and well-informed source, while a contemporary of Alexander should be regarded as "better at oratory than history" (Cicero's comment) and as an untrustworthy romantic fantasist. The former writer was Arrian, who wrote in Asia Minor in the mid–second century AD. The latter biographer is Cleitarchus, who wrote around 310 BC and produced a work twelve volumes long, of which only fragments survive. Cleitarchus wrote most of his work in Egypt. He never met Alexander or accompanied him on military campaigns, but he was, after all, a contemporary. So much for the distinction between "original sources" and "secondary sources."

Arrian's work is a pastiche of many fragmentary sources, none of which have survived in undiluted or complete form, with the exception of Plutarch. Arrian insists that he had all the accounts of Alexander laid out before him and could pick and choose what was reliable. In case you wonder why nearly all the biographies of Alexander are fragmentary, it is because of the Roman school system. Certain ancient accounts were

deemed classic, were used in the schools, and were widely available. Others were buried under the sands of time.

Arrian's major interest and competence were in military history. He made use of Callisthenes, who was Alexander's private historiographer and a nephew of Aristotle. Callisthenes's long and very detailed account, highly favorable to Alexander, ends abruptly in 327 BC, when Callisthenes was executed for complicity in a plot against his employer.

Another writer who accompanied Alexander for the entire duration of his campaigns was the Macedonian general Ptolemy, who composed a multivolume work that was available to Arrian. Ptolemy, after Alexander's death, became the founder of a dynasty that held the throne of the pharaohs for nearly three hundred years. He also hijacked much of the correspondence and other documents of Alexander's reign.

Among other writers consulted by Arrian were Astrolobus, an officer who served in Alexander's army; and Nearchus, an admiral who is believed to have exaggerated his own importance. The geographer Strabo, Curtius, and Diodorus tried to write substantial biographies, but only small fragments of these are available to us. All these writers as funneled through Arrian can be said to make up the "courtly tradition," the sober canon of Alexandrian studies.

The contemporary writer who founded the "vulgate," or popular tradition, was Cleitarchus. Much of his work survives, although he tells us many dubious and romantic stories. He pays attention to Alexander's sex life, which is more than

was done by the hard-bitten veteran soldiers who wrote Alexander's early biographies. Cleitarchus stands at the beginning of a long line of romance writers on Alexander who reached their apogee in the thirteenth century AD. By then we read fantasized tales such as the one about Alexander exploring the sea in a glass submarine.

Leaning toward the classical equivalent of the courtly tradition, but with an eye to the vulgate version, is Plutarch's *Parallel Lives*. Plutarch was a professional writer who wrote around AD 100. Paralleling Alexander and Julius Caesar, Plutarch takes pains to draw Alexander's character, and his is a finished, sophisticated work. The text of Plutarch's life of Alexander is (for once) fully extant.

Modern scholars are in sharp disagreement about the authenticity of *The Royal Journals*, an official diary of the king's reign, or presumed to be such. For the most part the entries are sparse as well as fragmentary, although statistics regarding the size of Alexander's army have been much mulled over. *The Royal Journals*, however, contain long, graphic accounts of Alexander's death.

The modern biographies are five in number: W. W. Tarn (1948); Robin Lane Fox (1973); N. G. L. Hammond (1980); A. B. Bosworth (1977); and Peter Green (1991). Tarn is notorious for claiming that Alexander was not a homosexual and that the king clearly propounded the brotherhood of man, an ideal derived from the Stoic philosophers. This was a cosmopolitan ideal in which ethnic separatism would give way to the social and cultural bringing together of Asia and Europe.

Every biographer since has claimed that this thesis is an anachronism or at least much overdrawn.

Bosworth and Hammond are good on military and administrative matters, although no modern biographer has seen fit to give the modern equivalents for the place-names along Alexander's route of conquest. It turns out that half of Alexander's fighting occurred in present-day Afghanistan, Uzbekistan, Tajikistan, and Pakistan.

This leaves Fox and Green, who have written the best—although quite different—profiles of Alexander. Fox wrote a prose epic. In Fox's view Alexander could do no wrong until he began to deteriorate in his last year. Fox's biography of Alexander is immensely detailed. Green is much more subdued and well balanced. All things considered, his is probably the best modern biography. But you must not miss the fun of reading Fox's Homeric epic, showered with prizes when it was first published. The fascination and awe with which Alexander was held are well communicated by Fox.

Curiously, two heavily illustrated books were published that aim to trace the complete route of Alexander's campaigns, one by Fox in 1980, and another by Michael Wood in 1997. Two books on the subject are redundant. One reads much about the authors' enduring scorching deserts, freezing mountains, cars breaking down, and sharing the humble food of tribesmen—who are, of course, always kind, peaceful, and generous. Fox's book covering this painful trail was subsidized by a foundation grant. Wood is not an academic, but that does not mean he is

not a scholar. He was subsidized by the BBC, which went along for the ride and filmed *In the Footsteps of Alexander the Great* for a BBC production with Wood as anchor and producer.

It is unfortunate that Fox and Wood could not find each other on the island of England and combine forces. Fox's book is sharp on art; Wood's book is more anthropological in nature, but both trace substantially the same fearsome journey. After reading Fox and Wood it is hard to avoid the impression that Alexander was half mad to follow these obscure and perilous routes.

If you take out a map of Central Asia and follow Alexander's route through Tajikistan, Afghanistan, and Pakistan, it is evident that Alexander could have avoided some of the mountainous and desert routes he traversed with his army. It seems that Alexander undertook this very arduous journey through these lands because he wanted to test himself as a great military leader who could journey to the end of the earth as well as establish an empire. It was a trial for his soldiers, too— whether they would follow him up cold mountains and through hot deserts. He saw the trip as more of an expedition than a conquest.

The impact of Alexander on the Mediterranean world has always been a subject for debate. A century after his death, Hellenistic Greek (*koine*) had replaced Aramaic as the international language of merchants, government officials, and intellectuals.

Even though under his successors the empire had split into three parts, Alexander's perpetual founding of cities named Alexandria in Egypt and Central Asia played a role in this Greek impact.

The populations of these outposts were Greek and Macedonian veterans buttressed by a polyglot merchant class. The only one of these seven Alexandrias that became a large and thriving city was the one in Egypt, which exceeded by far the old Egyptian capital of Memphis. In terms of both linguistic and economic interchange, the other Alexandrias had but a modest role to play.

Though Athens and Sparta remained independent, both city-states were much enfeebled and fell easy prey to Rome's rising power. Rome also conquered Egypt and Asia Minor. Yet something lingered from Alexander's effort at political unification. Bringing various parts of the Mediterranean world together set the policy and model for Rome. In a way the Rome of the Caesars was a continuation of Alexander's effort to create a world state.

To what extent the successor states to Alexander's were hellenized—that is, received the imprint of Greek culture—is a matter of dispute. On a positive note, one can point to a mastery of *koine* by an elite of higher government officials and merchants. As late as the Roman imperial era, wealthy Romans constantly kept a Greek slave, their *paedogogus*, so that their children were bilingual in both Greek and Latin. Greek nursemaids ensured that the babies learned Greek even before Latin. One can point also to the spread of Greek sculpture and

painting to every corner of the states ruled by Alexander's successors.

The ubiquity of Greek philosophy, especially Stoicism, among the aristocratic and intellectual classes indicates a cultural valorization occurring among the elite. Stoicism prescribed the joining of the human mind with the rational ordering of nature. In practice this meant not falling prey to passion and violence but holding oneself in restraint and calmness so as to be able to understand the rationality of the universe.

Yet according to Peter Green in *From Alexander to Actium* (1990), Alexander's effort to bridge Asia and Europe had only modest success. Linguistically, only a very small part of the population in Egypt and Asia learned Greek. These were bureaucrats and wealthy merchants. Cleopatra VII (*the* Cleopatra) was the only ruler of Egypt after Alexander's conquest who could converse in demotic (colloquial) Egyptian. Green compares the British impact on India and the post-Alexandrian Hellenic impact on Asia and Egypt and sees in both a very narrow band of smug elitists.

This view probably does a disservice to both hellenization and anglicization. After all, this narrow ribbon of upper-middle-class society was important in India, Asia, and Egypt, even though they comprised a very small part of the population. Green deems these classes of bureaucrats and merchants to be "boot-lickers" who greedily sought wealth and power, but this does not seem a judicious assessment of their social value, whether in Hellenistic society or postcolonial India.

Green has another point to make. It was the Romans, rather than Alexander and his Hellenistic successors, who did more to integrate the Mediterranean world. But it was Alexander, vague as his ideals and policies were, who initially broke down the isolation of Egypt-Asia from the Greek world. Even if the Greeks' own appreciation for cultural colonialism was modest, Alexander's achievements were a major step in that development.

Many things changed, however, with the rise of Islam in the seventh and eighth centuries AD. A process of linguistic dehellenization occurred. Arabic, not Greek, then became the common language of the eastern Mediterranean and has remained so to the present day.

Yet the advent of the Arab language in the eastern Mediterranean did not signify the obliteration of Hellenistic Greek culture. The impress of hellenization ran too deep for that. Greek philosophy, science, and medicine were translated into Arabic, and Greek ideas continued to exercise a strong influence for half a millennium of Islam.

It was only in the fourteenth century, with the rise of militant forms of Islam in North Africa, that cultural dehellenization profoundly altered the mind-set of the Arabic world. Deep into the Muslim and Arabic centuries, the impact of Alexander's empire continued to hold sway.

The Byzantine Greek emperor (the *basileus*), after AD 312 until Byzantium's demise in 1453, imitated the Alexandrian mode. He too wore a diadem, sat on an elevated throne, and mandated *proskynesis* from his subjects.

Hymns were sung by courtiers of the Byzantine emperor associating the imperial majesty of the *basileus* with divine authority. A courtiers' manual written down in tenth-century Byzantium carefully prescribed the duties and privileges of each Byzantine government official within this framework of the divine authority of the emperor.

The Russian Romanov dynasty down into the twentieth century was structured along Byzantine lines. Constantinople was the "second Rome"; Moscow the "third Rome." So Alexander's assumption of Persian traditions of kingship echoed down the centuries. Though Alexander lived to embrace the Persian traditions of kingship for only a decade, the consequences for the Western world were far-reaching.

Byzantine culture influenced the pattern of kingship for all kings in Western Europe during the early Middle Ages, except for an innovation (probably drawn from the Spanish Visigothic kings) by the Franco-German Carolingian emperors of AD 800 and subsequently. This involved the ceremony of anointing by which monarchs at their coronation are blessed with holy oil, the same way in which a bishop is anointed. This symbolizes that the king has been elevated to a God-given status.

The coronation ceremony of Queen Elizabeth II of Britain in 1953 demonstrated that this age-old tradition still continued. She sat on an elevated throne before which lesser mortals bowed and curtsied. Before she was actually crowned, she was given an anointing of holy oil on the palms of her hands, her breast, and her forehead.

Alexander's legacy influenced later European royal families

regarding the rituals of kingship. But Alexander taught them more than rituals; he taught the functioning and temperament of kingship. We have become used to the politics and institutions of what are, in effect, democratic republics. It is hard to think back to the advantages of kingship. But a strong king like Alexander could make lightning decisions, and the elaborate levels of bureaucracy, lobbyists, and political parties could be overborne by a king's early wise decision.

The temperament of kingship requires all focus to be placed on the king and his family. All eyes look upward; all hopes and expectations are concentrated on the king and the royal dynasty. No event is more important than the birth of a male heir to the throne, since on the shoulders of this infant will be cast the expectations of the next generation in society. Society could always hope that the royal lottery of a dynastic childbirth could give the people another heroic monarch, another world conqueror.

Since 1750 we have analyzed the defects and weaknesses of monarchy. For long centuries the Alexandrian political system was regarded as somewhat risky, but on the whole socially advantageous. Alexander added a special veneer to kingship. He lost at least a third of his army, but he made kingship glamorous by the force of his charisma and personal style.

This was not left to spontaneous chance. Alexander's royal propagandists worked long and skillfully to communicate the glory and anticipations of the return of the "great king," whether in orations or histories. His sculptors, painters, and

coin minters were adept at creating an irrefutably thick culture of dynasty. Art was an important form of state propaganda. The statues and friezes—and the coinage—of Alexander, widely distributed throughout his empire, were consciously intended to have a positive, comforting impact on society.

Alexander had his court artists develop a new style that we call Hellenistic art. It was grandiose, disproportional, exaggerated, propagandistic, even grotesque. It was not classicism, but it had a very strong influence on Roman art and became the genre in which sculpture, architecture, and painting were executed for half a millennium after Alexander.

Hellenistic style is meant to impress the conscious mind and to evoke awe in the subconscious. The sparse, clean lines of the Classical Era were superseded by the heaviness and ornamentation of an imperial style.

In these qualities Hellenistic art resembles another moment in imperial history—the colonial style of the British Empire in the first two decades of the twentieth century.

Examples of Hellenistic art were ornamental metal elephants, gargantuan statues symbolizing winged victory, and lighthouses twenty stories high at the entrance to harbors. There was a direct relationship between these exemplars and Alexander's military and political ambitions. So it was with British imperial and colonial art in the early twentieth century. Hotels then were designed as fortresses and office buildings had lavish rotundas, yet what must not be forgotten was the

tremendous skill of the Hellenistic and British architects and sculptors. It was an art of excess, but its craftsmanship was phenomenal and was endlessly reproduced.

The era of classical style in art endured for barely a century, from about 450 to 350 BC. The theme of classical art was adoration of the human body and buildings that accommodated the body but in a restrained and proportional way. Classical art sought to avoid hubris. This classical restraint is what distinguishes the sculptures and friezes on the Athenian Parthenon that Lord Elgin had moved to the British Museum.

The lore of Alexander achieved great renown in medieval Europe, particularly in the twelfth and thirteenth centuries. A literature of romance and fantasy circulated among the courts and cathedrals of Western Europe. But there is one point of social echo in this Alexandrian romantic literature. The medieval writers intuited that Alexander made extensive use of armored cavalry. Knights on horseback were for long years the key ingredient of medieval armies.

The immensely popular Alexandrian romances in the thirteenth century replaced the genre of the "matter of France" (Charlemagne and his knights). By 1300 the Alexandrian genre had been largely supplanted by the "matter of Britain" (King Arthur and his knights).

Aside from their recognition of the connection between Alexander's use of cavalry and medieval armored knights, there is another echo from Alexander's life that fascinated the

writers of the Middle Ages—Alexander's involvement with India. By 1200 the spice trade with India via Saudi Arabia added exotic necessary ingredients to the plain and simple European diet. India was known as the source of the spices now demanded by European cuisine and delicate palates. So Alexander's invasion of India was an additional fascinating dimension of his life that appealed to Europeans' imaginations—and to their stomachs.

The Alexandrian romances of the Middle Ages reflect a whole new type of literature that developed in the Hellenistic world. Critics now believe that the the novel was ultimately a product of Hellenistic culture. The romantic image of Alexander was itself a prime subject of these anticipations of the novelistic form.

The key to the life and behavior of the historical Alexander the Great lies in his belonging to a pre-Christian, thoroughly pagan world. He remained culturally and psychologically committed to an archaic Homeric time of heroic behavior.

Alexander belonged to an age of gods and heroes. It was a harsh, pitiless world of unremediated severity and cruelty, in which the laws of war, by which whole populations could be wiped out or sold into slavery, prevailed. It was a superstitious ambience requiring that the gods be propitiated, but these divinities were lacking in any ethical consciousness.

It was a world in which women were abused and prostitution was commonly acceptable. It was a moment in time

when pedophilic abuse passed without comment. Falling-down drunkenness was similarly viewed as manly and socially acceptable.

This culture produced Alexander, a man of incomparable heroism, who gloried in his physical strength and his battle-ready glamour. Overall the time was marked by a reckless, harsh ethos embedded in savage cruelty. This was Alexander's world, and he strutted on its stage as a colossus.

People today, because of better nutrition in childhood, are on average taller than at the time of Alexander the Great. But otherwise, biologically and psychologically, humans today and in Alexander's time are identical. We are wired the same way. Oedipal rebellion against a mother or father still affects growing up.

The difference between us and people of Alexander's day, particularly the Greeks, so often held up to us as role models, lies in the vastly different value system, not in biology or psychology. Nurture is as important as nature. The culture in which we grow up makes all the difference in our adult attitudes toward the value and sanctity of life.

In this cultural screening process it was Christianity that was most critical. Alexander was born into a pagan, pre-Christian world. His behavior was conditioned along certain lines—heroism, courage, strength, superstition, bisexuality, intoxication, cruelty. He bestrode Europe and Asia like a supernatural figure, and that is why his fame has not only endured but also become magnified and embellished by fantasy.

But he belonged to an archaic world. Christianity has screened us from that world and conditioned us to view life differently.

In 1974 a young Oxford don, Fox, tried to persuade us that Alexander was a kind of contemporary of ours. Except for Alexander's decline in the last year of his life, Fox attempted to posit this Macedonian prince, this idolizer of Achilles, as someone functioning within our own frame of values and therefore a thoroughly admirable person with whom we can identify.

In 1986 Fox wrote another book, *Pagans and Christians*, in which he dissected the differences in worldview of populations in the Roman Empire. Something critical has happened here; a cultural and religious line—Christianity—has been crossed.

How would Fox apply the lessons of *Pagans and Christians* to his first, early book on Alexander the Great? He could not apply them, for his epic, monumentally sympathetic account of the glorious Alexander could not have been written if the significance of the huge cultural upheaval of Christianity had been applied back to Alexander.

Fox's work of 1974 on Alexander dates from a period when Oxford was still basking in the postwar glow of Greek antiquity derived from Victorian times. *Pagans and Christians* appears to demand judgment on Alexander, which would be very unfair, because he is discovered to be a thoroughly pagan and pre-Christian personality.

In AD 312, the new Roman emperor, Constantine I, professed himself to be a Christian and set about supporting the church's bishops. In 313 Constantine issued an Edict of Toleration for

other religions. But in AD 395, Emperor Theodosius I canceled this act of toleration. The Roman Empire would thenceforth be a Christian state, and the temples of the pagan gods were closed.

These events, dictated by emperors, changed the worldview. They separated the now Christian Roman Empire from the Greek world of pagan antiquity. The birth of Christianity and its wide acceptance in the Western world brought about a vast cultural and political revolution.

Alexander the Great was the supreme exemplar of that old pagan world. He worshipped at the shrines of Zeus and other gods and even began to believe that Zeus was his father. Alexander represented himself as the image of the Homeric hero Achilles and brandished what he claimed was Achilles' magical shield.

Alexander emphasized the attributes of courage and strength. Under the laws of war he leveled cities and sold their inhabitants into slavery. He was merciless, even to those he cared for. He risked the dismay of his Companions, and when, in a drunken stupor, he killed one of his best friends, his act ultimately led to an assassination attempt against him. He had a lifelong gay lover; he consorted with whores; he was a drunkard.

The Athenian tragedians warned against arrogance, and Plato and Aristotle sought the refinements of reason. But these qualifications to the spirit of paganism did not seem to affect Alexander, although Aristotle had been his tutor in his early years. He sought glory on the battlefield, stole the Persian emperor's treasury, and disported himself like a Homeric

hero, all without conscience. In his lifetime he caused the deaths of half a million of his enemies' soldiers and accepted with apparent equanimity the loss of at least 25,000 of his own battle-hardened soldiers.

In time the church would educate heroic kings in an alternative ethic, never completely but at least partially. Christian kings, however, still yearned for the image of Alexander the Great. They sensed that at the dawn of recorded history there was a superhero with pagan values. And so, in spite of the application of another value system, Alexander remained, for the Middle Ages, a model king.

Alexander was, however, transformed in the European imagination. Stories about his life took on the gloss of Christian chivalry and courtliness. Twelfth-century romances sought to combine antique heroism with an up-to-date Christian sentimentality. The result was a species of magic realism or fantasy which had no connection to the real Alexander. Thus is history re-created from one era to another.

An image of a gruff and maniacal but brilliantly competent and self-assured personality imprints itself over time. Poets come along and re-create that image and gloss it over. The image takes on accoutrements of romanticization and idealism that depart from the natural, original, prosaic image and become intermixed in a new genre. Then some don—Le Fox—creates a new image of unexcelled glory.

To paraphrase L. P. Hartley (in his novel of 1953, *The Go-Between*), antiquity was another country; they did things

differently there. The Victorians were enamored of the Greeks and viewed them, especially the Athenians, as idealistic and compassionate people. After a hundred years of scholarship, we know better.

We would find the ancient Greeks a strange people indeed. They were courageous and bold to a fault, but they were also heartless and cruel. They slaughtered one another in trivial wars. They were superstitious and fanatical. They knew they were vulnerable, but an inner demon drove them into battle. With only swords, shields, and pikes to fight with, they inflicted catastrophic and terrible cutting wounds on one another.

The Greeks had little in the way of machinery, except to besiege cities. Yet they unflinchingly slaughtered one another in the name of honor. The strong man prevailed. All others were left for dead on the battlefield. The Greeks directed their strength and energy into making war. Then they sat around their campfires and recited stories about the heroes of old.

Because the Greeks had talented poets and artists, they were able to create from their bellicose and unpitying society an imaginative culture that impressed itself upon many later generations. The Romans were much like the Greeks, but the Romans established a peaceful empire built on the concept of law and order. They built aqueducts to bring water into their cities and built roads to carry their civilization to the ends of their empire. The Greeks had only heroes, who with a sense of honor laid waste to their cities and engaged in perpetual conflict unto death.

Alexander will always remain in the minds of most people

as "great." Even those who have not studied his life extensively have heard of his exploits in battle, his skill in military organization, and himself as a young man who accomplished great things before his untimely death. Regardless of his flaws, and they were many, he is seen as great because of who he was, not necessarily for what he did.[7]

Notes

ONE: *The Greek World*

1. A. B. Bosworth, *Conquest and Empire: The Reign of Alexander the Great* (New York: Cambridge University Press, 1988), p. 16.
2. Ibid., p. 10.
3. Waldemar Heckel and J. C. Yardley, eds., *Alexander the Great*, (Malden, Mass.: Blackwell, 2004), pp. 54–55, quoting Diodorus Siculus.
4. Ibid., pp. 56–57, quoting Quintus Curtius Rufus.
5. Plutarch, *The Life of Alexander*, trans. John Dryden, ed. Arthur Hugh Clough (New York: Modern Library, 2004), p. 3.
6. Peter Green, *Alexander of Macedon: 356–323 BC* (Berkeley: University of California Press, 1974), pp. 167–68.

TWO: *Who Was Alexander?*

1. Heckel and Yardley, *Alexander the Great*, pp. 28–29.
2. Ibid., p. 46, referring to Plutarch.
3. Ibid., p. 93, referring to Plutarch.

4. Robin Lane Fox, *Alexander the Great* (New York: Penguin, 1973), p. 54.

5. Ibid., p. 55.

6. Ibid., p. 56.

7. Heckel and Yardley, *Alexander the Great*, p. 42, quoting Valerius Maximum.

8. Ibid., quoting Aelian and Arrian.

9. Green, *Alexander of Macedon*, p. 89.

10. Ibid., p. 105.

11. Heckel and Yardley, *Alexander the Great*, p. 40–41, quoting Plutarch.

12. Ibid., p. 202, quoting Plutarch.

13. Ibid., p. 197, quoting Quintus Curtius Rufus.

14. Ibid., p. 41, quoting Aelian.

15. Fox, *Alexander the Great*, p. 150.

16. Heckel and Yardley, *Alexander the Great*, p. 220, quoting Plutarch.

17. Ibid., p. 37, quoting Aelian.

18. Ibid., pp. 279–80, quoting Diodorus Siculus.

19. Ibid., pp. 280–81, quoting Quintus Curtius Rufus.

THREE: *The March of Conquest*

1. Green, *Alexander of Macedon*, p. 114.

2. Ibid., p. 117.

3. Ibid., p. 123.

4. Ibid., pp. 133–35.

5. Ibid., p. 145.

6. Ibid., p. 148.

7. Ibid., p. 162–63.

8. Heckel and Yardley, *Alexander the Great*, p. 90, quoting Plutarch.

9. Ibid., p. 92, quoting Plutarch and Diodorus Siculus.

10. Ibid., p. 100, quoting Arrian.

11. Fox, *Alexander the Great*, p. 77.

12. Green, *Alexander of Macedon*, p. 165.

13. Heckel and Yardley, *Alexander the Great*, p. 93, quoting Plutarch.

14. Green, *Alexander of Macedon*, p. 181.

15. Ibid., p. 185.

16. Heckel and Yardley, *Alexander the Great*, p. 190, Plutarch.

17. Green, *Alexander of Macedon*, p. 219.

18. Ibid., pp. 220, 221.

19. Heckel and Yardley, *Alexander the Great*, pp. 105, 106, referring to Quintus Curtius Rufus.

20. Ibid., pp. 107, 108, referring to Justin.

21. Green, *Alexander of Macedon*, p. 241.

22. Ibid., p. 251.

23. Ibid., p. 263, quoting the prophet Zachariah.

24. Ibid., p. 267.

25. Ibid., p. 290.

26. Heckel and Yardley, *Alexander the Great*, p. 120–21, referring to Quintus Curtius Rufus.

27. Fox, *Alexander the Great*, p. 253.

28. Green, *Alexander of Macedon*, p. 328–29.

29. Ibid., p. 331.

30. Fox, *Alexander the Great*, p. 273.

31. Ibid., p. 321.

32. Green, *Alexander of Macedon*, p. 335.

33. Ibid., pp. 361–64.

34. Ibid., p. 381.

35. Heckel and Yardley, *Alexander the Great*, pp. 123–27, referring to Arrian.

36. Ibid., pp. 128–31, referring to Arrian.

37. Fox, *Alexander the Great*, p. 369.

38. Heckel and Yardley, *Alexander the Great*, p. 269, quoting Arrian.

39. Green, *Alexander of Macedon*, p. 410.

FOUR: *The Last Years*

1. Green, *Alexander of Macedon*, p. 419.
2. Bosworth, *Conquest and Empire*, p. 138.
3. Ian Worthington, ed., *Alexander the Great* (New York: Routledge, 2003), p. 165.
4. Ibid., p. 164–65.
5. Green, *Alexander of Macedon*, p. 434–35.
6. Ibid., p. 443.
7. Ibid., p. 447.
8. Plutarch, p. 68.
9. Bosworth, *Conquest and Empire*, p. 171.
10. Heckel and Yardley, *Alexander the Great*, p. 274, quoting Plutarch.

FIVE: *How "Great" Was Alexander?*

1. Partha Bose, *Alexander the Great's Art of Strategy* (New York: Gotham, 2003), pp. 19–20.
2. Heckel and Yardley, *Alexander the Great*, p. 299, quoting Livy.
3. Bosworth, *Conquest and Empire*, p. 181.
4. Claude Mossé, *Alexander: Destiny and Myth* (Baltimore, Md.: Johns Hopkins University Press, 2004), p. 171.
5. Heckel and Yardley, *Alexander the Great*, p. 297–98, quoting Livy.
6. Ibid., p. 297–298.
7. Worthington, *Alexander the Great*, p. 166.

Bibliography

Bose, Partha. *Alexander the Great's Art of Strategy.* New York: Penguin, 2003.

Bosworth, A. B. *Conquest and Empire: The Reign of Alexander the Great.* New York: Cambridge University Press, 1988.

———, and E. J. Baynham, eds. *Alexander the Great in Fact and Fiction.* New York: Oxford University Press, 2000.

Etienne, Roland, and Françoise Etienne. *The Search for Ancient Greece.* New York: Abrams, 1990.

Fox, Robin Lane. *Alexander the Great.* New York: Penguin, 1974/1986.

———. *In the Footsteps of Alexander.* Boston: Little Brown, 1980.

Garland, Robert. *The Greek Way of Life.* Ithaca, N.Y.: Cornell University Press, 1990.

Green, Peter. *Alexander of Macedon: 356–323 B.C.* Berkeley: University of California Press, 1974.

———. *Alexander to Actium: The Historical Evolution of the Hellenistic Age.* Berkeley: University of California Press, 1990.

Hammond, N. G. L. *Alexander the Great: King, Commander and Statesman.* London: Chatto and Windus, 1981.

Bibliography

Heckel, Waldemar, and Yardley, J. C., eds. *Alexander the Great: Historical Texts in Translation*. Malden, Mass.: Blackwell, 2004.

Holt, Frank L. *Alexander the Great and the Mystery of the Elephant Medallions*. Berkeley: University of California Press, 2003.

Jenkyns, Richard. *The Victorians and Ancient Greece*. Cambridge, Mass.: Harvard University Press, 1980.

Keuls, Eva C. *The Reign of the Phallus: Sexual Politics in Ancient Athens*. Berkeley: University of California Press, 1985.

Kitt, H. D. *The Greeks*. New York: Penguin, 1985.

Mossé, Claude. *Alexander, Destiny and Myth*. Baltimore, Md.: Johns Hopkins University Press, 2004.

Orrieux, Claude, and Pauline Schmitt Pantel. *A History of Ancient Greece*. Malden, Mass.: Blackwell, 1997.

Rostovtzeff, Michael. *The Social and Economic History of the Hellenistic World*. 3 vols. Oxford, England: Oxford University Press, 1941.

Shipley, Graham. *The Greek World After Alexander, 323–30 BC*. New York: Routledge, 2000.

Tarn, W. W. *Alexander the Great*. 2 vols. New York: Cambridge University Press, 1948.

Wood, Michael. *In the Footsteps of Alexander the Great*. Berkeley: University of California Press, 1997.

Worthington, Ian, ed. *Alexander the Great*. New York: Routledge, 2003.